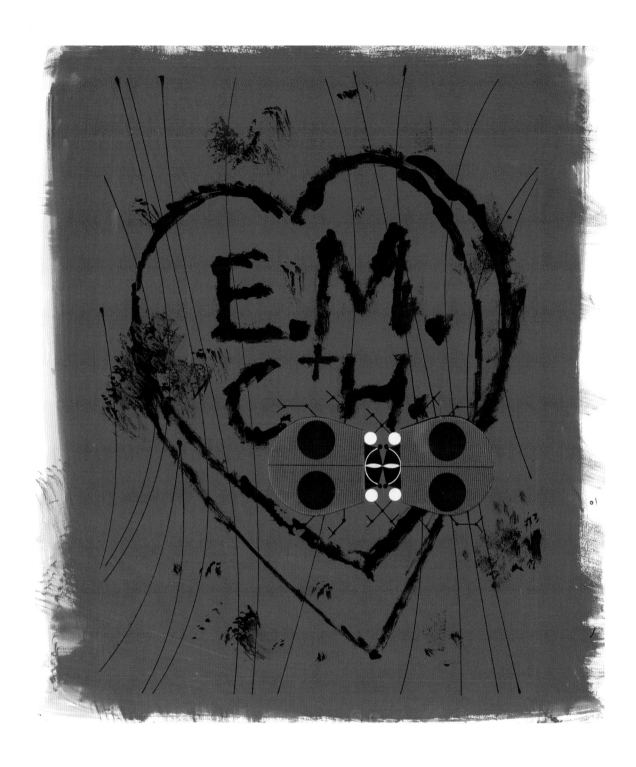

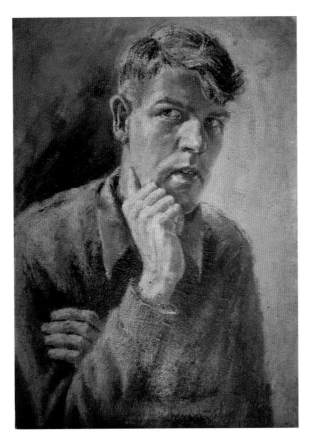

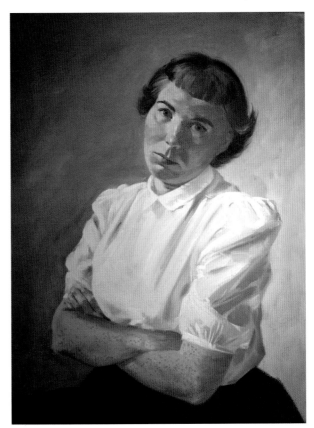

Edie Harper
Edie Self-Portrait, 1947
Oil on canvas, 26 x 19 in.

Charley Harper
Portrait of Charley, 1947
Oil on canvas, 32 x 26 in.

The Early Work of **Charley and Edie Harper**

HARPER
Ever After

Essay by **Sara Caswell-Pearce**
Introduction and Commentary by **Brett Harper**
Tribute by **Chip Doyle**

Pomegranate
Portland, Oregon

FRONT COVER: Charley Harper
Feeding Station, 1954
Serigraph, 18¼ x 13 in.
Cover of *Ford Times* magazine, November 1954

BACK COVER: Edie Harper
Woodland Fauna, 1948
Oil on canvas, 48¼ x 72⅛ in.

PREVIOUS: Charley Harper
Harper Ever After (EM+CH), 1963
Cut paper and gouache on board, 18 x 13½ in.

"E.M.+C.H." stands for the love of Edith McKee and Charley Harper. He made this painting of kissing ladybugs against one of his favorite trees, the beech. The Harper home and studio were enveloped by a virgin forest of close to sixty majestic beech trees, creating a secluded sanctuary that both Charley and Edie loved.

Pomegranate Communications, Inc.
19018 NE Portal Way, Portland OR 97230
800 227 1428 • www.pomegranate.com

Pomegranate Europe Ltd.
Unit 1, Heathcote Business Centre
Hurlbutt Road, Warwick
Warwickshire CV34 6TD, UK
[+44] 0 1926 430111 • sales@pomeurope.co.uk

To learn about new releases and special offers from Pomegranate, please visit www.pomegranate.com and sign up for our e-mail newsletter. For all other queries, see "Contact Us" on our home page.

Library of Congress Cataloging-in-Publication Data

Harper ever after : the early work of Charley and Edie Harper / Essay by Sara Caswell-Pearce ; Introduction and Commentary by Brett Harper ; Tribute by Chip Doyle.
 pages cm
 Includes index.
 Summary: "Early artworks by Charley Harper and Edie McKee Harper. Includes 200 full-color reproductions and historical photographs"-- Provided by publisher.
 ISBN 978-0-7649-7146-4 (alk. paper)
 1. Harper, Charley, 1922-2007--Themes, motives. 2. Harper, Edie--Themes, motives. I. Caswell-Pearce, Sara. II. Harper, Brett, 1953- III. Harper, Charley, 1922-2007. Works. Selections. IV. Harper, Edie. Works. Selections.
 N6537.H3495H37 2015
 740.92'2--dc23
 2014036667

Pomegranate Item No. A238
ISBN 978-0-7649-7146-4

Designed by J. Spittler / Jamison Design

Printed in China
24 23 22 21 20 19 18 17 16 15 10 9 8 7 6 5 4 3 2 1

Contents

Acknowledgments

I want to take this opportunity to recognize Chip Doyle, curator and archivist for the Charley and Edie Harper Art Studio. He and his associates worked tirelessly for months to select, conserve, frame, and mount the glorious 2013 exhibition *Harper Ever After* at the Art Academy of Cincinnati. I also credit Chip for coming up with the title of the exhibition, which in turn inspired my idea for this book. I'd like to acknowledge a special thanks to Chris Hennig and photographer Ross Van Pelt. I would also like to thank the following:

Art Academy of Cincinnati Alumni Association

Bob Beeghly

Zoe Katherine Burke

Matthew Dayler and his printmaking class, Art Academy of Cincinnati

Rob Deslongchamps

Jonathan Doyle

Kim Everett

Dudley Fisher

Matt Graham

Jennifer Hardin

Jack Hennen

Ashley Johns

Marjorie and George Keil

Casey Kinane

Adam Lee Musselman

Melissa Norris

Sarah Noschang

Jennifer Pettigrew

Suzanne Sifri

Sandy Smith-Harper

John Sullivan

Eric Michael Tollefson

Denise Watson

Sarah Wrobel

—Brett Harper

A Tribute to **Charley and Edie Harper**

A dozen or so years ago on a most pleasant afternoon, I had the honor of being involved in the opening of an amazing art time capsule with Edie, Charley, and Brett Harper. It was in the form of a footlocker that had been tucked away under the stairs of the Harper studio and, for the most part, forgotten for more than fifty years.

At that moment, I had no idea that what we discovered would have such an impact on the telling of the Harper story, but I did know these works were special and deserved to be preserved, shared, and celebrated. Much to my surprise, Edie and Charley, in all of their modesty, made statements like, "Oh, those old things?" But as we sifted through the pieces, they opened the floodgates to memories of teachers, classes, friends, and experiences while at the Art Academy of Cincinnati. They were transported back in time—once again the young couple brought together through their love of art and each other.

The collection of artwork and photographs presented in this book illustrates the beginning of one of the greatest love stories: *Harper Ever After*.

—Chip Doyle
Curator, *Harper Ever After* exhibition
Curator and Archivist, Charley and Edie Harper Art Studio

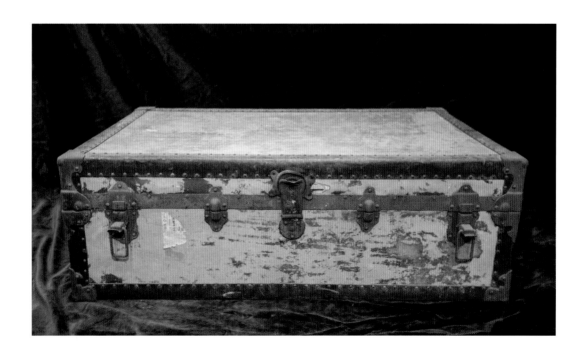

Introduction
The Formative Years

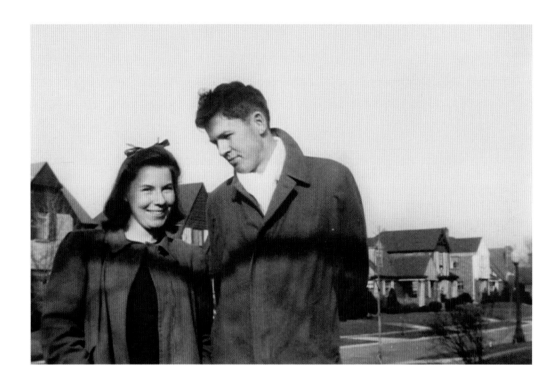

On September 10, 1940, two excited students met on their first day of school at the Art Academy of Cincinnati. Was it on the worn stone step still bearing witness today at the entrance to the administration building of the old Eden Park campus? Or in Mr. William Hentschel's class as he took attendance?

She was Edie McKee, a girl from Kansas who graduated from Wyoming High School in Cincinnati. He was Charley Harper, a farm boy from West Virginia who had already spent a year in the art program at West Virginia Wesleyan College, copying wall calendars as instructed and wanting so much more. His sympathetic art teacher had suggested that he check out the Art Academy of Cincinnati. So, with his mother crying and father stoically watching, he boarded a train for the three-hundred-mile trip to Cincinnati.

From that first day they were inseparable friends, sharing positive opinions of Paul Klee, Picasso, Ben Shahn, Vasily Kandinsky, Edward Weston, Paul Strand, Joan Miró, and other modern artists. Edie and Charley passionately compared their own student efforts with each other and shared the doubts and insecurities they felt—from their own anxieties as eighteen-year-olds to parental concerns about their future financial prospects and societal assumptions that making art was of little value. As Charley once said, "Where I come from, the only time people mention art is when they call out a guy's name."

Those were heady years to be art students at the Art Academy of Cincinnati, an institution with a venerable history beginning in 1887 with painter Frank Duveneck. The school's mission was to train students in all art media over three years and turn out well-rounded artists. (The Academy did not institute a four-year program until 1950.) Edie and Charley benefited from a host of exceptional teachers. They sketched nude models in a foundational drawing class. In sculpture class, they sculpted facemasks of themselves. They absorbed the "aquatone" airbrush technique of William Hentschel, de rigueur for mastering the addition of soft textures in painting or for those aspiring to careers in industrial advertising. Myer Abel, Herman Wessel, John Weis, Frank Myers, and Reginald Grooms taught painting. Then there was the printmaking class with the young couple Willson Stamper and his wife, graphic arts instructor Maybelle, who taught stone lithography, etching, and serigraphy. (Maybelle's personality and mystical philosophies of art exercised a siren-like sway over Edie and Charley—so much so that when the Stampers later divorced and Maybelle adopted an isolated life on a patch of beach on Captiva Island, Florida, Edie and Charley would stay with her for a while on their honeymoon journey.) Arthur Helwig, the trim, urbane sketching instructor with a goatee, looked very much like a caricature of himself: he had studied in Paris, France, under cubist painter Jean Marchand. (When I was a little boy and my father would take me to the academy, I would see Helwig with his then-white goatee, strolling down the hall as I approached the academy secretary, Madeline Mohrman. She would save used postage stamps for me, gleaned from the many envelopes of international mail she processed.)

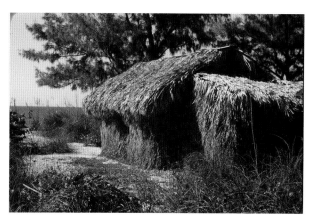

Maybelle Stamper's "Palmetto House" on Captiva Island, Florida, where Edie and Charley Harper visited her during their honeymoon.

Academy students organized field trips and fun social events to showcase their flair for both creative expression and hijinks. One of the highlights was the academy costume ball, a tradition that still continues.

Mabel and George McKee welcomed Charley as their daughter's suitor, although Mabel referred to him formally as Charles Harper until the end of her life, and she once severely reprimanded him for inviting Edie to his off-campus apartment and serving ravioli. Her ire was not caused by the quality of his cooking but by his failure to arrange to have a chaperone present. Charley's parents and his two older sisters fussed over Edie, an only child. She fondly recalled visiting West Virginia for the holidays and partaking of good country cooking. Charley, in turn, affectionately referred to her parents as the "Kees."

War had been on the horizon even when Charley and Edie started at the academy, and in 1942, when America needed troops for the European campaign against Nazi Germany, Charley was drafted as a private first class in the army. He was sent to basic training at army camps in Arkansas and Colorado,

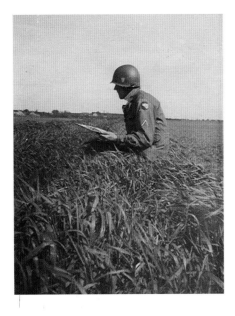

Charley learning to "work fast and loose" during World War II.

and then learned mapmaking and drafting at the University of Delaware. He was sent overseas to Cherbourg, France, as an infantry scout in a reconnaissance platoon, arriving September 7, 1944.

Edie, meanwhile, opted to aid the war effort in her own way after she graduated from the academy in 1943. Because she was already a skilled photographer, she found relevant employment in the US Army Corps of Engineers. Edie had learned the art and darkroom processing of photography from Fritz Van Houten Raymond, who had also served as the photographer for nearby Rookwood Pottery Company. (His teaching career at the academy lasted a remarkable seventy-seven years, and he lived to the age of 101. Raymond had even photographed the Spanish-American War, using creek water in Cuba to develop his negatives in the wet-plate collodion process.) In her new job, she photographed cross sections of concrete samples and processed them, providing vital information for engineers who tested the strength of materials to withstand the landing weight of aircraft on forward airstrips near Japan. Beyond that, Edie's photographs of hydroelectric dams in Ohio, Indiana, and Kentucky were used to assess the capacity of the nation's water management infrastructure to survive attack.

She was exceedingly busy during this period, working and helping with the care of her father—who was afflicted with multiple sclerosis—and taking night classes at the academy to supplement the skills already mastered through her degree.

Charley did his best to hone his artistic abilities while in the army. He credited his battlefield experience with helping him "work fast and loose," virtues in his subsequent commercial art studio environment. He illustrated for soldiers' magazines and

drew and painted portraits of his comrades for their wives, girlfriends, and families in his off-duty time.

Upon the surrender of Germany, Charley shook hands with the Russian troops at the Elbe River and was sent home by transport across the Atlantic. In New York City, he wrote to one of his sisters that he never felt prouder to be an American. He had made it through unscathed except for mental wounds: he and his advance unit had liberated Nordhausen and other concentration camps, leading him to question for many decades God's plan for humanity.

Edie's work was included in a three-person show at the Cincinnati Art Museum in late 1944 that had been quite well received, but it was the return of her "Buzzie," her Charley, that was the highlight. The newly rejoined couple had another scare when Charley was ordered to Camp Pendleton, California, to train for an assault on mainland Japan. This was canceled when the United States dropped atomic bombs on Hiroshima and Nagasaki, and Charley was able to go back home.

In 1946, Charley took advantage of the academy's relationship with the Art Students League of New York to study there for a semester. Afterward, the league arranged a job for him in the city and found him a place to live—a barn in Stamford, Connecticut—but he returned to West Virginia to "lick [his] wounds" for four months. He realized that New York was not for him, even if it was the art capital of America, and he decided he wanted to complete his training at the academy on the GI Bill. Plus, he missed Edie.

Back together again in Cincinnati, Charley was able to focus on finishing his studies back at the academy, and Edie was able to focus on her art. And they focused on each other. Charley was hired to design covers for Procter & Gamble's corporate magazine titled *Moonbeams* while continuing his studies.

In 1947, Charley won the Stephen H. Wilder Traveling Scholarship upon graduation. As part of the award, he was honored with a solo exhibition of his work. The scholarship gave him $1,000—equivalent to $10,600 in today's currency—plus a free paid semester of tuition at the academy. Edie left her job at the Corps of Engineers.

On August 9, 1947, Charley and Edie were married in the living room of her parents' small brick home in the Cincinnati suburb of Roselawn. It was a simple ceremony with just a few of their academy friends. With Charley's scholarship money and Edie's parents' Chevrolet, the newlyweds embarked on the "Great Honeymoon." It would be a six-month marathon trip, crisscrossing America. Everywhere they traveled, they painted—often the same object or scene, which allowed for friendly critiques of each other's interpretation. Charley and Edie would drive for as long as they felt like during a given day, then pull over along the road if they hadn't reached a state or national park, or the home of a friend or relative.

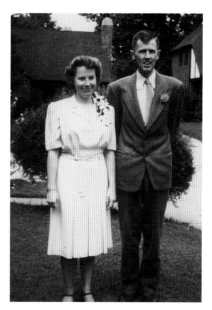

Edie and Charley on their wedding day, 1947.

After they returned from their honeymoon, Edie and Charley settled in the Roselawn home with her parents. This living arrangement enabled the newlyweds to continue assisting Edie's father with his daily needs. It also allowed them to save money to afford the purchase of a five-acre wooded tract and contemporary house ten years later. This sanctuary would include an attached studio for Charley, and it would be their home for the rest of their lives.

But it was downstairs in the McKees' basement that Edie and Charley established a joint studio, and in the garage, they silkscreened prints on a hand press. Edie always mixed the ink colors by sight for those prints, of which the earliest were nursery rhymes. An academy friend built a clever rack for them, made of tightly spaced strings, for drying the wet prints. Occasionally other friends would drop by and help pull prints or stack them on the drying rack.

Soon, Charley started work at Studio Art in downtown Cincinnati. In 1948, he was invited to show his portfolio to the art director of *Ford Times* and other Ford Motor Company consumer magazines. He began a thirty-seven-year relationship that generated hundreds of commissions for illustrations (and some stories). Charley made serigraphs of birds and travel subjects from the magazine right there in the McKees' basement. (He sold them for $4.95 plus fifty cents postage. Today these vintage prints sell for many times the original price.) Charley happily could depend on recurring checks from Ford, providing some financial stability at the dawn of his art career.

On October 10, 1949, Edie and Charley returned to the Cincinnati Art Academy to attend the color theory course taught by the renowned Bauhaus artist Josef Albers. Albers was making his way back to Yale after serving as an important presence among other luminaries at the legendary Black Mountain College in Asheville, North Carolina. It was a measure of the academy's standing that Albers included it in the handful of institutions where he taught. The gruff, no-nonsense German scolded one student, "Miss, you have ambition without reason." Edie felt comfortable that she had escaped such contempt: he sent her personal Christmas cards for several consecutive years following the course.

In 1949 as well, Edie and Charley eagerly participated in the Modern Art Society in Cincinnati (renamed the Contemporary Arts Center in 1956). The society had recently held exhibitions showcasing the work of such distinguished artists as Arshile Gorky, Robert Motherwell, Rufino Tamayo, Juan Gris, and Henri Matisse, among many others. Even outside art aficionado circles, the city was certainly no backwater in the swelling river of postwar modern art. For instance, Joan Miró was commissioned to paint a mural in the Gourmet Restaurant (the mural now resides opposite the Cincinnati Art Museum café). Today, Cincinnati remains a thriving art community. Todd Oldham, the renowned New York–based designer who has done so much to rekindle awareness of my father's work, has praised the outsized level of creativity in a city the size of Cincinnati. "There must be something in the water," he quipped. Whether its water, air, or topography is the cause, I agree that Cincinnati is a place rich with gifted artists.

In 1960, Charley got an important break. Through an art agent, the Golden Press in New York commissioned him to illustrate a children's textbook, *The Giant Golden Book of Biology*. Working day and night, from seven in the morning until midnight, he completed the project in a year. This was the job that

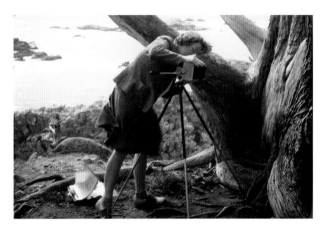

Edie setting up her camera on Point Lobos, California, during their honeymoon in 1947.

gave Charley the confidence and security to declare his independence and become a freelance artist. Now he could leave the studio and have the reasonable expectation that clients would seek him out. Edie was happy, because she was weary of accompanying him to the studio's all-night office parties, which invariably gave her migraine headaches.

After Edie left the government photo lab, she focused on her own abstract photography, making 8 x 10-inch plates with a cumbersome camera that she lugged around with a tripod. By the mid 1950s she was highly respected as a fine art photographer. In 1961, the Contemporary Arts Center honored her with a solo exhibition titled *Edith McKee Harper: Exhibition of Photographs*. Charley taught illustration and design part time at the Art Academy of Cincinnati for twenty years beginning in 1957. He told me he did so in order to bring some of the skills of a commercial artist to the academy students, in hopes of making them more readily employable. But he wasn't too crazy about the faculty meetings and the rancor between the "young Turks" of abstract expressionism and the venerable Dean Herbert Barnett, still producing quasi-cubist

masterpieces at mid-century and after. I found out much later that he also taught those classes to supplement his income so he could help send me to college.

The artworks presented in this book reflect Charley and Edie's development as artists, from their first days at the Art Academy of Cincinnati, when they learned basic concepts and were influenced by the styles of their instructors, to their discovery of their own styles and identities as artists. I see this book and the exhibition based on these early works, first shown at the academy in 2013, as an expression of my love for the academy and for its students, who, I believe, can benefit from knowing that their forerunners also fought to find their own voices in art.

The academy has meant so much to me throughout my life. After all, I would not even be here if it weren't for a spark between two earnest art students, Edie and Charley, almost seventy-five years ago.

—Brett Harper
Cincinnati, Ohio, August 2014

Photograph from 35 mm color slide
taken on the Harpers' honeymoon.

EDITH McKEE HARPER

"I have come to regard photography as an art form equal in
importance and satisfaction to painting. As a painter-
photographer I find that each medium contributes immeasurably
to the other, that my photographs suggest new approaches to
painting, that my painting helps me to compose on the ground
glass with fresh vision. The same instincts, thought processes,
and techniques are imployed, inversely, in both media: in
making a painting I add; in making a photograph I subtract,
select until I have isolated in an 8" x 10" area a newly conceived
little universe which exists as a unique experience in seeing
and is in no way dependent for its meaning upon the ordinary
objects whose familiar shapes inspired it."

Edie's artist statement for her 1961 solo exhibition
at the Contemporary Arts Center, Cincinnati.

Abstract photographic composition, late 1950s.

Photograph by Edie Harper, late 1950s.

Birds of a Feather
The Art and Marriage of Charley and Edie Harper

by Sara Caswell-Pearce

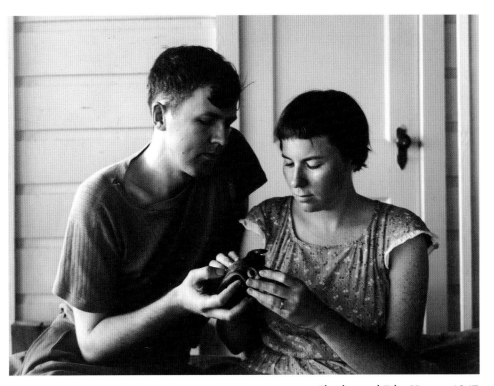

Charley and Edie Harper, 1947.

If artists are lucky, there is a moment when their work reaches a mass audience, when they rise above being local or regional, and become national, or maybe even international, names. Then, with even more luck, they find one fan (or one finds them) to rekindle that moment for a new generation of art lovers.

Both moments happened for Cincinnati artists Charley and Edie Harper. Already nationally known in the 1970s and 1980s, by the 1990s, much of the buzz had died down. Then, a young New York-based designer, Todd Oldham, rediscovered his love for the couple's work, and they would once again be household names.

Well, only Charley would be, at first. Harper's bold, minimal compositions of birds and animals are the very definition of mid-century modern design—the kind of geometric, playful, nature-inspired graphics that appeared on tabletops, wallpaper, upholstery and linens in the late 1940s and well into the 1950s. It was 2002, and Oldham was in the vanguard of a revival of the cool, uncluttered look of American design. He was part of a young generation rediscovering furniture, accessories, and art that were affordable, hip and retro, yet fresh.

Oldham had admired Charley's work since childhood via a copy of *The Giant Golden Book of Biology* (Golden Press, 1961), an oversized children's book crammed with Charley's highly stylized insects, flowers, animals, and people. In adulthood, Oldham found Charley's work at a junk store in Pennsylvania, where he stumbled upon copies of *Ford Times* magazine with cover illustrations by Charley. "I saw the cover, and something went crazy in my head, so I bought all I could, and I finally figured out how I knew it—that Charley had done it," he told the *New York Times* in 2011. "When I figured it out, I knew I wanted to meet him."[1]

Oldham did just that in 2002 while in Cincinnati for a modernism convention. At the time, Charley was ill and in the hospital. But Oldham kept returning, and Charley kept recovering. Oldham drove to the modern Harper home/studio nestled in a grove of beech trees in the Cincinnati suburb of Finneytown.

There Oldham discovered a treasure trove of art, as well as something that Cincinnatians had known for decades: there was another Harper, Edie. She, too, was an artist—a versatile one who worked in a variety of mediums, including photography, beadwork, fiber, enamel, silkscreen printing, and painting. She never became a commercial artist as Charley did, although she did publish books, exhibit, and continually create.

Oldham adapted Charley's work for fabric upholstery for chairs, sofas, ottomans, and recliners he designed for La-Z-Boy, and hung silkscreen prints by Charley in the La-Z-Boy New York boutique. Oldham included Charley's work in his DIY manual *Handmade Modern: Mid-Century Inspired Projects for Your Home* (Harper Design, 2005); wrote about him on his web site; and produced the book *Charley Harper: An Illustrated Life* (AMMO Books, 2007), a mammoth coffee table book that took the design world by storm—and reintroduced Charley's work to a worldwide audience.

Since then, Oldham has published more Harper books, and Charley *and* Edie's work has become ubiquitous, a gift shop and bookstore staple. Their art is on everything from calendars, puzzles, coasters, and skateboards to dish towels, coffee mugs, fabric, T-shirts, and board books. There are needlework patterns, gift wrap, bird sculptures, tiles, and Christmas tree ornaments. And, of course, prints, posters, and paintings.

All of this has made it easy to think of the Harpers as designers, rather than fine artists.

But the chance discovery of a weathered footlocker filled with the Harpers' art from their youth and years as students at the Art Academy of Cincinnati casts them in a new light. It shows their versatility, skill, and grounding in the fine arts, and puts Edie on an equal footing with Charley.

Anything Was Possible

Charles Burton Harper and Edith Riley McKee—both born in 1922—were artists from the start, drawing and painting throughout their childhoods, he on a farm in Frenchton, West Virginia, a small town nestled in the foothills of the Appalachian Mountains, northeast of Charleston, and later, in nearby French Creek, and she in Kansas and Missouri, before the family's move to Roselawn, a northern suburb of Cincinnati.

Charley was isolated from the art world until he attended West Virginia Wesleyan College, and there he had limited exposure. He yearned to attend a real art school. He wrote on his Art Academy of Cincinnati application that he had heard about the academy from his art professor Miss Leta Snodgrass.

Later, when he would return home for summer breaks, he was thrown straight back into a rural culture. He wrote to Edie in July 1941,

> "I wish you were here sketching with me. It's not so much fun alone . . . and I do long for somebody who will comment on something besides 'good likeness' in my drawings.
>
> "You know, the thing about art that discourages me most is that nobody but artists think they understand it. And I find I'm almost living in a world alone here.
>
> "Sure an' it's a nice world to live alone in, but it becomes monstrous when there is nobody around who talks your language. Honestly, I've practically forgotten all I know about cubism and stuff."

Edie, on the other hand, had taken Saturday-morning sketching classes at the academy while she was a student at Wyoming High School, where she "began drawing attention for creating art at a level beyond her years," wrote the *Cincinnati Enquirer* in her 2010 obituary.[2]

When they hit the Art Academy of Cincinnati in the fall of 1940—in a now legendary meeting on the first day of school, they, like all art students, were primed for experimentation. The *Cincinnati Enquirer* interviewed Edie when an exhibition of Charley's work opened at the Cincinnati Museum of Natural History, "They met in a golden moment—'the first second of the first day of the first class with the same teacher . . . not exactly love at first sight,' she said, but they've been painting together ever since. And it 'works really pretty good.'"[3]

They grew up during tumultuous times. The aftermath of the Great War with its terrible loss of life collided with the economic free fall of the Great Depression, then war again. The impact was profound on every aspect of life, including the making of art. There had been shifts in the art world before, changes that had seemed cataclysmic at the time. But compared to what was to come, they were mere tweaks on traditional painting, sculpture, architecture, and the decorative arts.

But it was in painting that the most radical change would occur.

The impressionists, with their focus on the effects of light, had stretched the definition of realistic painting, and the post-impressionists took it even further. But it was the emotionalism of the expressionists, the avant-garde absurdism of the Dadaists and surrealists, the unconventional perspective of the cubists, and the focus on machines and mechanics of the futurists that totally upturned art and propelled it

into the twentieth century. In his essay "The Machine Age," Eric de Chassey writes, "As of 1915 in New York, the reexamination of traditional conceptions of art had reached such proportions that it gave rise to the equivalent of what the Europeans would call Dada" and to *artistes provocateurs*.[4]

In short, anything was possible.

At the time, the academy still held to a rigorous schedule of fundamentals. It required each student to take a general course that offered a "foundation in the principles of drawing and painting, to familiarize the student with various techniques and media, and to provide an understanding of line, color, form, light and shade, abstract and pictorial design."[5] Anatomy was also required, as well as a two-hour-a-week class on the development of painting. There was a strict and high standard in drawing.

Cincinnati had continued to embrace, and bask in the glow of, its late nineteenth-century Golden Age artists—European-trained, realistic painters such as Henry Farny, Frank Duveneck, Lewis Henry Meakin, and John Twachtman. Some, such as Duveneck and Meakin, had returned home to work and teach at the academy, where their influence would be felt for decades as their students went on to teach future generations.

Art galleries favored local work, and the Cincinnati Art Museum—the first purpose-built art museum west of the Allegheny Mountains—actively purchased it for its deep and growing encyclopedic collection.

On the flip side, there was a keen awareness of the growing impact of commercial art and both decorative and industrial design. Cincinnati was home to Procter & Gamble (the world's largest consumer products company), Formica Products Company, Baldwin Piano Company, Gibson Greetings, Inc., Rookwood Pottery Company, and the United States Playing Card Company (makers of the ubiquitous Bicycle Playing Cards), all major advertisers in the booming magazine and newspaper industries. The city also had a rich heritage of printing that included Strobridge Lithography Company (renowned for its vivid advertising posters and circus posters for Ringling Bros. and Barnum & Bailey) and Ault & Wiborg Company, whose letterpress and lithographic inks were used by fine artists worldwide, including French artist Henri de Toulouse-Lautrec.

"There is a greater demand for this kind of artist today than at any other time," noted the 1939–1940 academy catalog. "We have only to notice our textiles . . . our automobiles, lighting fixtures, architecture, metal grills, glassware, china, carpets, rugs, advertisements, posters, cards and all sorts of printed matter to realize the vast field covered by industrial design." That same catalog touted academy alumni such as advertising artist and book illustrator Wilbur G. Adam, illustrator Herman E. Bischoff, industrial designer Russel Wright, and lithographer Carl Frederick Moellman.

The stock market crash had led manufacturers to reconsider product design. In his essay "The Machine between Cult Object and Merchandise" Olivier Lugon writes, "Making products more desirable seemed to many to be the ready-made solution to a crisis perceived as a mere problem of under consumption. . . . In this way, a new profession was born that deeply marked the American imagination of the 1930s—that of industrial designer."[6] A few years later, in 1941, Edie would give Charley a gift subscription to *Fortune* magazine with a card whose message read, "Your Christmas gift is a year of Fortune . . . the living record of the strange new world we all are working in today."

At the academy, Charley and Edie gravitated toward teachers William Hentschel, Maybelle Stamper, and her husband Willson Stamper, who were skilled in decorative design, graphic arts, and commercial art. Hentschel had designed textiles, wallpaper, and pottery for Cincinnati's renowned Rookwood Pottery Company, where he produced thousands of designs. He would become a mentor to Charley, overseeing Charley's Stephen H. Wilder Traveling Scholarship in 1947, and his revolutionary "aquatone" airbrush technique would influence some of Edie's work.

Maybelle Stamper's cryptic, offbeat, and often mystical drawings and prints inspired Edie to paint and print her own series of mysterious, abstract images. In *Abstract (Lantern)*, a primordial creature appears within a tube surrounded by a curling, red thread that appears to be an umbilical cord. In *From Within* (p. 53) a landscape is centered in a tunnel of wavy lines that could be the inside of a cave, or the view from within an eye. In *Third Kind* (p. 67) she painted an unsettling trio of alien-like beings with marshmallow-shaped heads and deep-set, questioning eyes who peer straight at the viewer. She painted a dynamic series of works that include the light-dappled nightscape *Summer Night* (p. 52), the paler, dancing *Twilight* (p. 53), and the ethereal *Cosmos* (p. 67) with its makeshift constellations and staring eyes.

Like most art students', at first Charley and Edie's work was highly imitative. They experimented with a variety of styles, mediums, and techniques, trying them on for size.

Klee's signature patchwork of color, seen in such famous works as the 1922 portrait *Senecio*, is picked up by Charley in *Beach Day Dreaming* (p. 109) and *Netted Fish*. In the 1952 serigraph *Grand Canyon #2* (p. 120), Charley's horizontal layers resemble those in Klee's 1929 landscape *Highways and Byways*.

Edie and Charley collaborated on *To the Moon and Back* (p. 70), in which a giant yellow moon and red, white, and yellow planets burst out of a darkened space, much like Miró's restive, abstracted images. Edie's Miró-inspired *Traffic Light* (p. 34) pulses

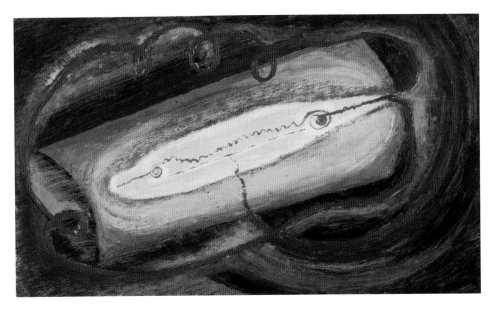

Edie McKee
Abstract (Lantern), n.d.
Oil on board, 8 x 13 in.

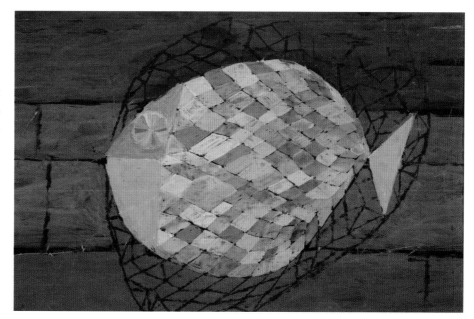

Charley Harper
Netted Fish, n.d.
Gouache on paper, 12 x 19 in.

with red, green, and yellow light, and her *Abstract (Red Eyes)* (p. 66) is a surreal creature with red eyes beaming from undulating black appendages.

They dabbled in realism, drawing and painting portraits of one another, as well as self-portraits and other figurative work. They penned cartoons, sketched classic nudes, and painted jaunty landscapes and cityscapes. The paintings show the influence of Austrian-born illustrator Ludwig Bemelmans, whose series of *Madeline* children's books, his most famous works, are illustrated in the same breezy style.

The Harpers employed every medium and tool at hand: ink, pen, pencil, watercolors, oils, gouache, charcoal, etching presses, lithography stones, scratchboard, silkscreens, collage, photography, boards, and paper.

Charley's *Eden Park*, (p. 54) a stark, abstract landscape, marked a new direction for him; it was his first nonrealistic painting. He would later say that by the time he graduated, he felt that realism "revealed nothing about the subject that nature hadn't done better."[7]

Her print of a neighborhood tavern, *Three Knights in a Bar* (p. 56), has the rough-and-tumble hallmarks of Ashcan School paintings that captured the prosaic side of urban life. Her lively *Maestro* (p. 71) channels cubism's fragmentation and pays homage to Spanish-born artist Pablo Picasso by way of a background painting within the painting that depicts a pair of harlequins (Picasso's alter ego). Edie designed distinctive, childlike patterns that exemplified the bold style of 1940s textiles, later reproduced as wrapping paper (pp. 44–45). She tried her hand at conventional fashion illustrations, advertising art, and genre scenes.

They collaborated on pieces, and, frequently, it is difficult to tell who created a piece, or contributed what to it. "We went to art school together, and we compared notes, and liked the same people," Charley told Todd Oldham, adding, "When we would go to exhibitions, we almost invariably liked the same pictures."[8] They were able to mine the Cincinnati Art Museum's collection, which spanned

six thousand years and included tens of thousands of objects. Academy students had ready access to it, as well as to the museum library, because the academy was not only affiliated with the art museum, it was physically connected to it.

A Time to Do Something Final

All of this was interrupted when Charley was drafted into the army during World War II, as a private first class, and eventually sent to Europe. He was officially a clerk in the Intelligence and Reconnaissance Platoon of the 414th Regiment, 104th Infantry Division, but the regiment chaplain knew about his art background and carried Charley's art supplies for him in his pack.

Charley sketched and painted realistic images of fellow soldiers, war-ravaged towns, and grim battle scenes. "I'm about to lose my feeling for abstraction, and unreality, because here life suddenly became very real, and nothing but realism can portray it," he wrote to Edie on February 10, 1945. "Later I'll have time, I hope, to do some abstractions of the same subjects from the sketches I'm doing now. My sketches are sort of shorthand notes." He had little choice but to work quickly, just as he had in life drawing class with five-minute poses, to capture the essence of a moment.

Charley's landscapes are sad, dreary, and lifeless, in stark contrast to frontline scenes bursting with action as soldiers cut through a burned-out forest, shooting as they go, and tanks crawl on top of men trapped in trenches (pp. 86–87). He painted on whatever he could find. An ammunition box served as the substrate for *Stroll through Oblivion*, a powerful painting in which two brightly clothed children pick their way through a smoky, bombed-out town. They are dwarfed by the wreckage, but appear undaunted.

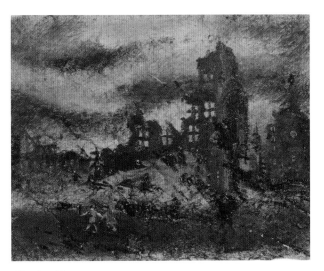

Charley Harper
Stroll through Oblivion, 1944–1945
Gouache and oil on ammunition box, 7 x 9 in.

He jumped at the chance to create illustrations for a history of his division, known as the Timberwolves. "If you haven't heard from me for some time, it's because I've been busier than usual, doing something every minute of which I have enjoyed," he wrote to Edie on January 11, 1945. "I've worked three days now, and finished four drawings. I'm sorry the job is done, because it isn't every day I get to devote all my attention to drawing."

Edie, meanwhile, was taking night classes at the academy. Her work was selected for an exhibition by the Cincinnati Modern Art Society (founded in 1939, later evolving into the Contemporary Arts Center) in which she was asked to show her work in an exhibition with two other former academy students. "You can bet that if there weren't an ocean between us, I'd be at your exhibition," he wrote on January 22, 1945, in reply to two letters from her. "I can hardly stand it to see your name on that announcement."

Charley did some cartooning, submitting pieces to *Yank*, the army weekly magazine, although he didn't have aspirations as a cartoonist. He admired the work of Bill Mauldin. The cartoonist was just a year older than Charley and had all the bravado of youth. Mauldin was unemployed when he enlisted in the army in 1940, but was soon cartooning for the *45th Division News*. He endeared himself to the troops with his unsanitized depiction of the war, and would go on to win two Pulitzer Prizes for editorial cartooning. Charley wrote to Edie on January 3, 1945, "I hope your paper has Mauldin's cartoons, because he does the most true to life army cartoons you'll see." He continued, "All of us here appreciate every one of them, because they express something we have felt, but didn't know how to tell so forcefully and cleverly."

By the time Charley returned to America, Edie had graduated from the academy and was working as a photographer and photo lab technician in the Cincinnati office of the US Army Corps of Engineers, which had a long tradition of hiring artists. But instead of returning to Cincinnati, Charley went to New York City, attending the Art Students League of New York, an independent school founded in 1875 that was open to anyone who wanted to attend. He was taking advantage of the GI Bill, a law passed in 1944 that provided a variety of benefits to help World War II veterans return to everyday life, including tuition and living expenses to attend college.

He hated New York.

In letter after letter to Edie, he writes about his homesickness, the noisiness and unfriendliness of the city, his inability to get into specific courses, overcrowded classes that left him sitting on the floor or far from models, monitors running classes rather than teachers, and the indifference of teachers who rarely looked at, let alone critiqued, his work. "I was so sure I'd like it here," he wrote to Edie on January 19, 1946. "I was going to work madly, even in my room. Now, I hardly have the will to walk to class."

During that first month, he was leaving, giving it a few more days, leaving, giving it until the end of the month, leaving, giving it until the end of the term. "I'm sure you long ago regarded me as the most undecided creature of your acquaintance, and every day here, I am adding to my list of accomplishments in that field," he wrote to Edie on January 15. In the end, he stayed through the term.

"Since I've made up my mind to stay here a while, I've been getting your letters answering my sad and bitter ones of the first few weeks," he wrote to Edie on January 26. "If I'd got them, I'm sure I wouldn't have stayed. All I needed to make me go from here was a letter or two from you to make me sure you'd understand and forgive me. But if I had left, I'm afraid I'd have felt defeated the rest of my natural life."

He began to take advantage of the city's cultural assets, attending concerts, catching documentary films, visiting museums, and popping into gallery exhibitions. He wrote to Edie that the Metropolitan Museum of Art was a disappointment. "It's so big, I was lost 10 times," he wrote. "Saw nothing exciting. All old masters. Every picture had a huge gold frame."

He had similar feelings about the Whitney Museum of American Art and the Frick Collection. "The show they had was part of their permanent collection, and what a mess!" he wrote to Edie after a visit to the Whitney. "We really ripped it apart . . . the way we screamed at those pictures, you'd have thought the pictures themselves were to blame for being so bad . . . some surrealistic things were all we really liked."

He reveled in the galleries. "It's wonderful, for two blocks you can walk into one gallery and go into another next door—for free," he wrote to Edie in February about the galleries on East 57th Street. He was fresh from seeing one-person exhibitions of paintings by expressionist Milton Avery, social realist Robert Gwathmey, landscapist Maurice Grosser, abstract artist I. Rice Pereira, realist Helen Harvey Shotwell, and printmaker Harry Shokler. "Avery is truly wonderful. His things are refreshingly simple. A few shapes, beautiful color . . . then, we saw the Gwathmey show; it, too, was truly wonderful . . . his figures are beautiful and simple, color is same. I was aching for you to see it. Ummm—so good." After having taken silkscreen classes at the academy, he was particularly pleased to see the serigraphs by Shokler, a pioneer in the medium who had studied at the academy.

The city and the school were starting to have an impact on his work. The portfolio he was showing was brimming with his realistic war art, but he pushed himself toward abstraction. On March 20 he wrote about experimental abstracts he was making with colored paper for Vaclav Vytlacil's class, "I am going to shock him with quantity this week. . . . For once, I am doing things I enjoy, and think are half decent in Vyt's class. But if I listened to the class, I'd be thwarted. Some of them say, 'Nice exercises.' The monitor said, 'Nice designs for wallpaper.'" Few examples of his league work exist but a colorful New York harbor scene (p. 72), foreshadowing later work with its lithe lines.

He never really clicked at the league. "Bosa discouraged me again," he wrote to Edie on May 6, referring to instructor Louis Bosa, a painter of emotional street scenes in which subjects are treated with affection and humor. "Said the landscapes I did over the weekend still had no soul, were too slick and sweet. He harps on that so much I'm beginning to think I have no soul to put into my pictures."

By June, he was back in West Virginia, having fled "to the serenity of the hills" for the summer.[9] By fall, he had been readmitted to the Art Academy of Cincinnati.

He brought home plenty of lessons from Europe and New York. In the heat of war, he had become a more polished artist, and in the unruly atmosphere of the league, he had learned to create work that spoke to him. His style had begun to change.

Edie had quit her job to help care for her father, yet she continued maturing as an artist. This would become even more evident during their six-month honeymoon trip across America in 1947, a camping trip funded by the academy when Charley won the school's first Stephen H. Wilder scholarship for postgraduate travel. The announcement was made in May 1947, just before his graduation. "The Art Academy achieved its real masterpiece with scholarship awards, just t'other day," declared the Cincinnati Times-Star in its May 9 edition. "Charles Harper was declared the outstanding student when the $1,000 Wilder Traveling Scholarship was nestled in his hands. More than 60 students entered work in the competition, which was judged by the Academy faculty."

It was time, Charley decided, to propose to Edie. "Our friendship developed in class . . . and we just became accustomed to each other," he told Oldham many years later. "And it came to a head when I got the scholarship, and I thought that was a time to do something final."[10] They were married in August, then hit the road in her Chevrolet, which he described in a August 28, 1947, letter as

one of us, a third person (talked about constantly but never speaking), really

24

the most important member of our party. We treat it like a tender little child, attending alertly all its whims and fancies, listening like cats for every noise that seems different . . . we apologize to it when we hit unexpected bumps too hard, pat the dashboard comfortingly. Silly, aren't we?

They toured the American West, stopping at Yellowstone, Grand Canyon, and Rocky Mountain national parks, sketching humorous cartoons, snapping photographs, and, always, painting. We go out and get our eyes full, and then come back to our 'little home' and empty them—making pictures," Edie wrote to a friend named Marjorie Keil in a September 30 letter from Crescent City, California. "Chars has done right well—has made 17 watercolors since we have been here. . . . My count is not as high, but am workin' at it."

Edie was busy, too, taking photographs, setting up darkroom after darkroom as they traveled. She had long admired the work of pioneering modern photographers Paul Strand, Alfred Stieglitz, and Edward Weston. While in California, they visited Weston's house, and, surrounded by his many cats, purchased one of his black-and-white photographs for twenty-five dollars. Later, she and Charley would name their only son, Brett, after one of Weston's sons.

Charley had begun to look for ways to reduce the landscape to patterns and designs. Edie would do the same in works such as *Through Kentucky* (p. 114), an oil painting in which blue hills appear as large, rounded mounds topped by and covered with simple triangular tree shapes. Seen side by side, Charley and Edie's *Oregon Coast* paintings (p. 26) appear to be studies by a single artist. Horses

graze on a sliver of horizon in Edie's *Sunflower* (p. 100), while a throng of people stand along a similarly narrow strip in Charley's *Grand Canyon #1* (pp. 106–107).

When they returned home, they established a studio in the basement of Edie's parents' home in Roselawn. Charley, desperate for work, landed a job at Studio Art, a downtown Cincinnati commercial studio founded in 1919 by Cliff Schaten that would become LPK, an international branding agency, in 1983.

Today, it might be called a soul-sucking job. It forced him back into the direction he was moving away from: realism. But it wasn't a total loss. He learned new techniques and the basics of typography. "Commercial art is a good training ground for any kind of artist who wants to communicate with people, and for me communication is an important part of art," he told the *Cincinnati Enquirer*.[11] Even so, he had no qualms later talking about how much he detested the work, which he would often refer to as "happy housewife art."

He found outlets for abstraction as a freelancer for *Ford Times*, a monthly magazine published by the automobile company. The same dramatic, above-below composition that had first appeared while he and Edie were on their honeymoon, reappears in illustrations for *Ford Times*, but in a cleaner, more sophisticated, and linear manner (pp. 121, 124).

At first, he created lighthearted vignettes with cars, then, he moved on to a series featuring birds and fish that would anticipate his later style of minimal realism. "We liked very much his *Eight Familiar Fish*, their smart design and singular style, especially the little *Crappie* which lends itself so charmingly to the repeating design that hangs next to the group," read a review by art critic Mary L. Alexander of an exhibition of his work at the academy.[12]

Here, the Harpers painted the same Oregon coast scene with different results.

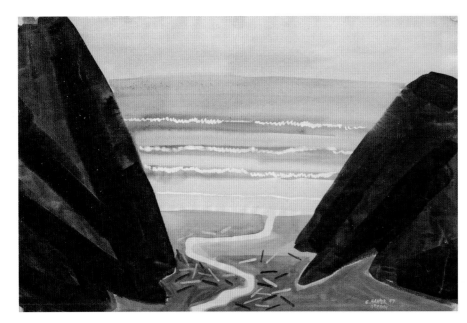

Charley Harper
Oregon Coast, 1947
Watercolor on paper, 12 x 17¼ in.

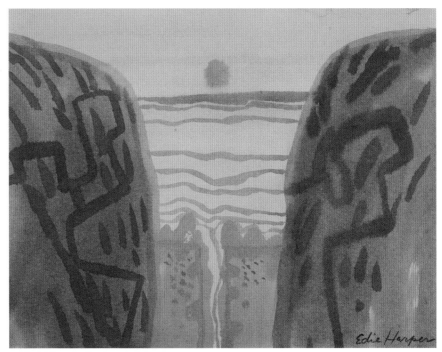

Edie Harper
Oregon Coast, 1947
Watercolor on paper, 9½ x 12½ in.

Charley Harper
Crappie, 1952
Serigraph, 13 x 18½ in.

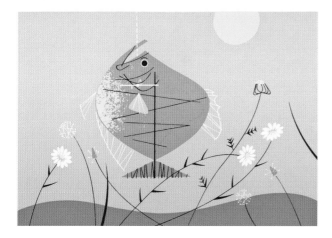

The wildlife illustrations were so popular that requests started streaming in for prints, so he and Edie established their own print studio, Harper Prints. Eventually, Charley left his job at Studio Art to strike out on his own. Working side by side, Edie and Charley continued "making pictures" as they had done on their honeymoon trip so many years before—but now in their very own light-filled home they both loved so much, surrounded by nature.

Through the contents of the discovered foot-locker, we see the story of two artists who grew up, found their own unique artistic styles, and built a life—together. From the free-spirited self-discovery of youth and art school through the traumas and separations of war, and from the anxieties of making a living from their art through the sacrifices of raising a family, Charley and Edie had to rely on each other. Knowing this, both long-time fans and those new to the name can approach the Harpers' mature work with a greater appreciation, and admiration, for what they created together.

Notes

1. Rima Suqi, "Currents | Q & A: Todd Oldham," Home & Garden, *New York Times*, June 15, 2011.

2. Barry M. Hortsman, "Edie Harper, Artist, Had Whimsical, Abstract Style," *Cincinnati Enquirer*, January 26, 2010.

3. Rosemary Munsen, "Artist Loves Ladybugs," *Cincinnati Enquirer*, August 28, 1981.

4. Eric de Chassey, "The Machine Age," in *American Art 1908-1947: From Winslow Homer to Jackson Pollock*, ed. Eric de Chassey (New York: Harry N. Abrams, 2002).

5. Art Academy of Cincinnati catalog, 1939–1940.

6. Olivier Lugon, "The Machine between Cult Object and Merchandise," in *American Art 1908-1947: From Winslow Homer to Jackson Pollock*, ed. Eric de Chassey (New York: Harry N. Abrams, 2002).

7. Charley Harper, "Charley Harper Interviews Charley Harper," in *Beguiled by the Wild: The Art of Charley Harper* (Gaithersburg, Maryland: Flower Valley Press, 1994).

8. Todd Oldham, "Conversation with Charley Harper," *Charley Harper: An Illustrated Life* (Los Angeles: AMMO Books Ltd., 2007).

9. Exhibition brochure, Frame House Gallery, Louisville, Kentucky, November 1969.

10. Oldham, "Conversation with Charley Harper."

11. Owen Findsen, "A Different Kind of Bird," *Cincinnati Enquirer*, August 23, 1981.

12. Mary L. Alexander, "Work of Charles Harper Shown in Academy He Knew as Student and Where He Now Teaches Art," *Cincinnati Enquirer*, January 17, 1954.

Art Students 1940–1947

Charley Harper, Art Academy years, n.d.
Photograph by Edie McKee

Edie McKee, Art Academy years, n.d.
Photograph by Fritz Van Houten Raymond

Charley and Edie met on their first day of school at the Art Academy of Cincinnati. Charley had spent a year at West Virginia Wesleyan College, right after high school. Their studies were interrupted by World War II, after which Charley spent a semester at the Art Students League of New York, before returning to the Art Academy in 1946; he graduated in 1947. Edie graduated in 1943.

Charley identified *Early Wildlife Scene* as his first nature painting. It was produced during his brief stay at West Virginia Wesleyan College.

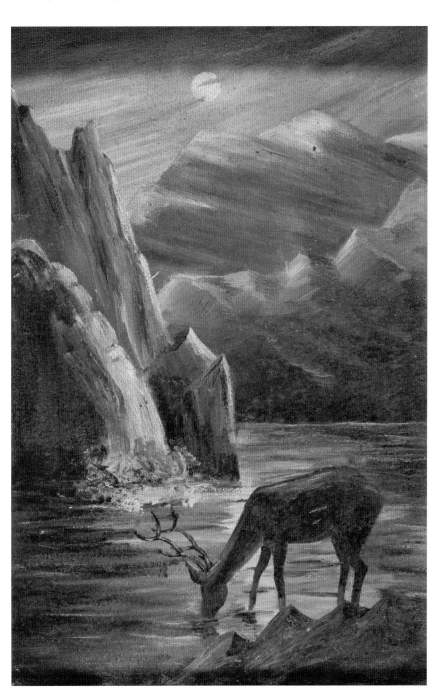

Charley Harper
Early Wildlife Scene, 1940
Oil on board, 18 x 12 in.

Charley Harper
At the Exhibit, n.d.
Ink on paper, 10½ x 12 in.

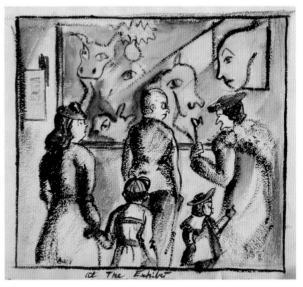

Charley Harper
Charley (Self-Portrait), n.d.
Ink on paper, 18 x 12 in.

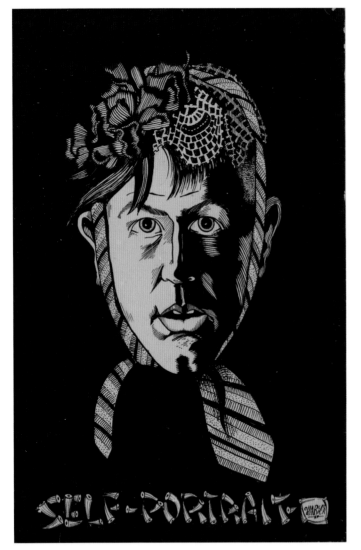

Edie McKee
Artist's Praise, n.d.
Charcoal on paper, 18½ x 15½ in.

Charley Harper
Coffee Grinder Still Life, n.d.
Gouache on board, 17 x 20 in.

Charley Harper
Me in Class, 1940
Graphite on paper, 13½ x 10¾ in.

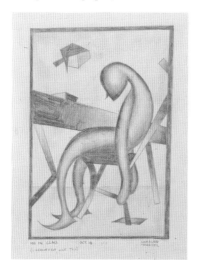

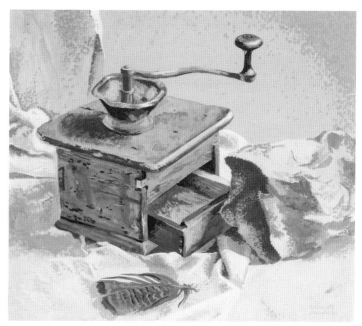

Edie McKee
Primary Colors, n.d.
Oil on paper, 15¼ x 20 in.

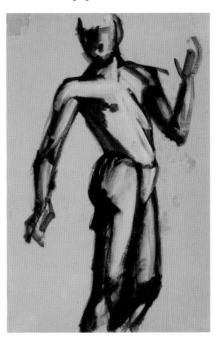

Edie McKee
Man, n.d.
Gouache on paper, 20 x 13 in.

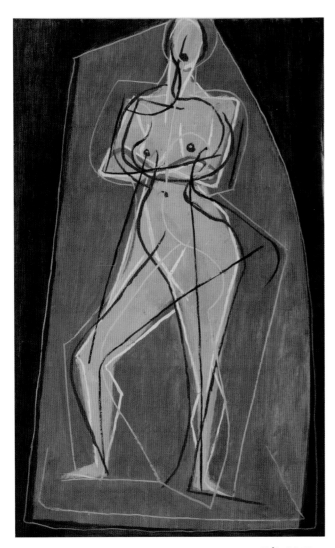

Edie McKee
Abstract Nude, n.d.
Oil on paper, 20 x 15 in.

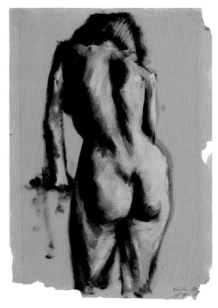

Edie McKee
Woman, n.d.
Oil on paper, 18 x 14 in.

Charley Harper
Tilting Windmills, n.d.
Cut paper and gouache on board, 12 x 17½ in.

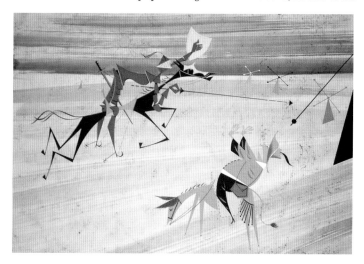

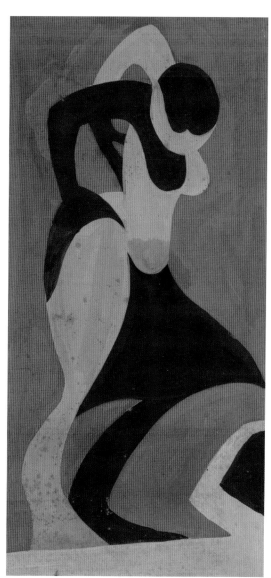

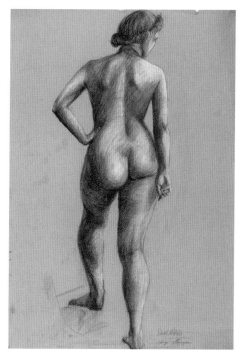

Charley Harper
Abstract, n.d.
Gouache on paper, 12½ x 6 in.

Edie McKee
Backside (Nude), n.d.
Charcoal on paper, 25 x 17 in.

Edie McKee
Plein Air (15 min. study), n.d.
Oil on board, 14 x 11 in.

Edie McKee
Traffic Light, n.d.
Oil on board, 17 x 10 in.

Edie McKee
Stairway to Immaculata, n.d.
Watercolor on paper, 20 x 13 in.

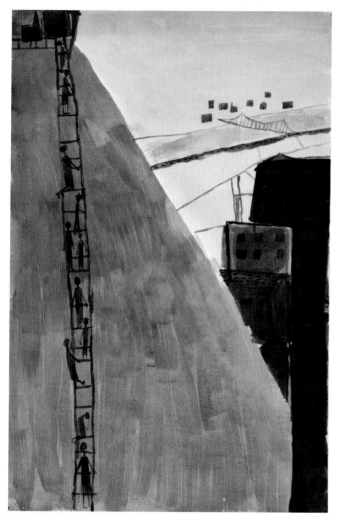

Edie McKee
Garden, n.d.
Oil on board, 8 x 11 in.

Stairway to Immaculata portrays the annual ascent of the Catholic faithful on their knees, climbing step by step up the stairs to the Church of the Immaculata at the summit of Mount Adams, one of the seven hills of Cincinnati.

Charley Harper
Fetch, n.d.
Halftone, gouache, and ink on paper, 13 x 18 in.

Charley Harper
Harvest, n.d.
Ink and gouache on paper, 12 x 15 in.

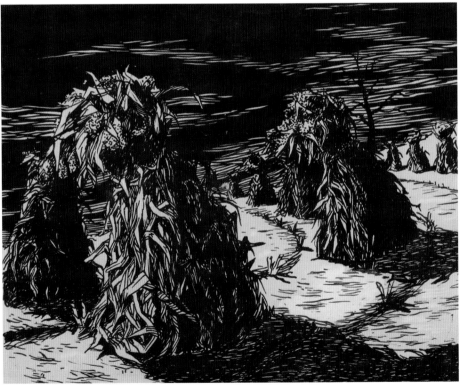

Charley was all too familiar with shucking corn on his family's farm in West Virginia.

Edie McKee
Charley, n.d.
Scratchboard, 10 x 7 in.

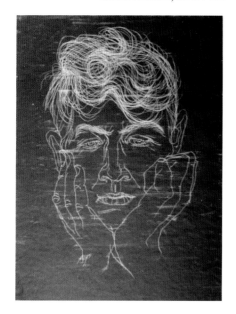

Edie McKee
Drawing (study), n.d.
Graphite on paper, 22 x 17 in.

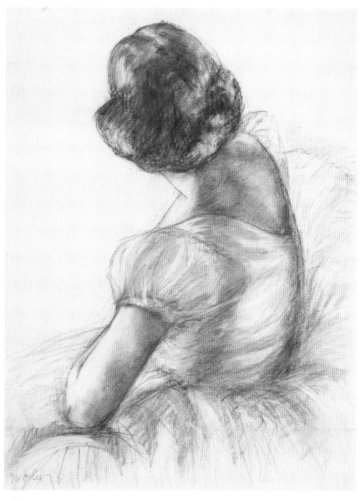

Edie McKee
Ballerina, n.d.
Charcoal on paper, 25 x 19 in.

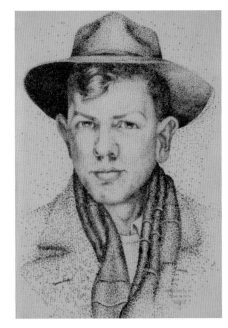

Charley Harper
Charley, 1941
Ink on paper, 19 x 13 in.

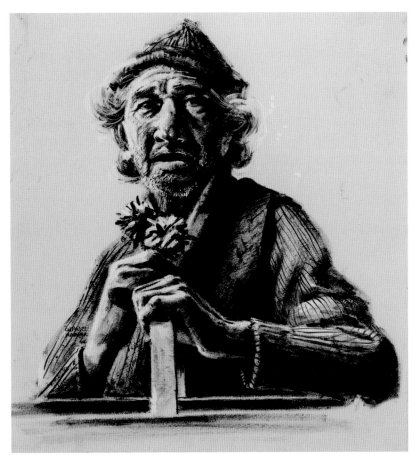

Charley Harper
Man in Hat Holding Basket, n.d.
Gouache and india ink on board,
14 x 13¼ in.

Charley Harper
Portrait of a Woman, n.d.
Gouache and watercolor on board,
12 x 9 in.

Charley Harper
Edie Pie (Charley's pet name for Edie), n.d.
Stone lithograph, 10½ x 9 in.

Edie McKee
Modeling Dresses, n.d.
Watercolor on board, 13½ x 10 in.

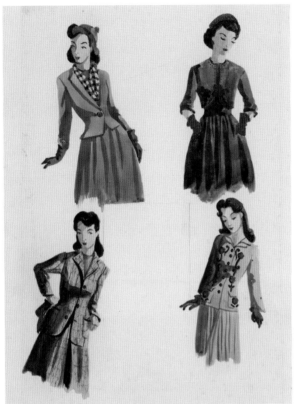

Edie McKee
Girl in Dress (Black and White), n.d.
Watercolor on board, 11½ x 9½ in.

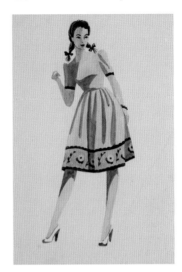

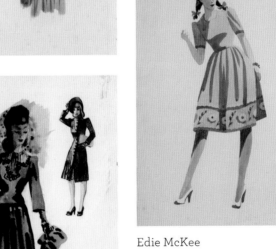

Edie McKee
Girl in Green Dress, n.d.
Watercolor on board, 11½ x 9½ in.

Edie McKee
Two Elegant Ladies, 1940
India ink on paper, 15 x 10 in.

Edie's fashion art ranged from women's dresses to accessories and shoes.

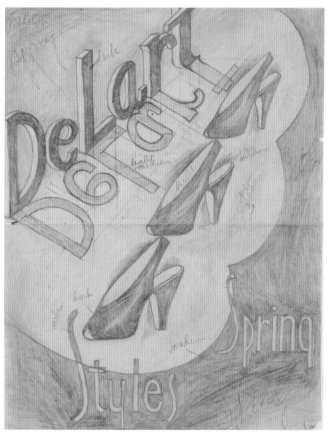

Edie McKee
DeLart Styles (Black and White), n.d.
Graphite on paper, 11 x 8½ in.

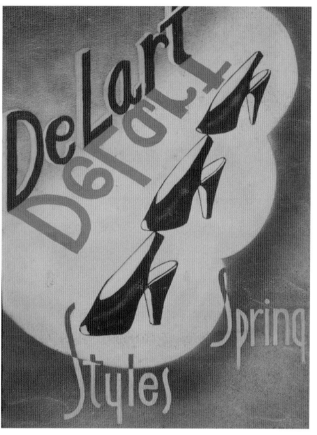

Edie McKee
DeLart Styles (Purple), n.d.
Airbrushed mixed media and gouache on paper, 11 x 8 in.

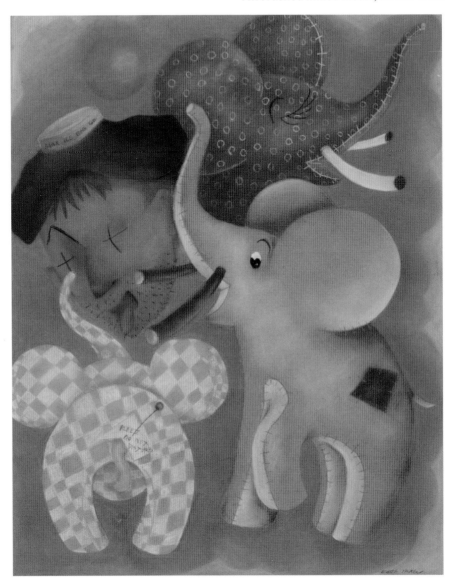

An example of Edie's application of airbrushing taught by academy instructor William Hentschel. The technique, once the domain of highly paid commercial artists, is today all but abandoned, replaced by computer software applications.

Edie Harper
Alphabet Soup, n.d.
Airbrush, 22 x 17 in.

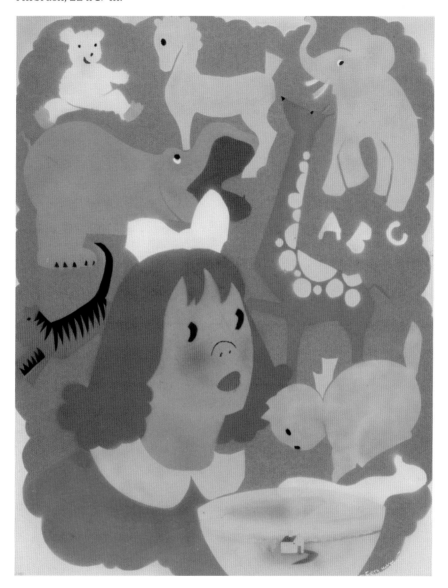

A sweet medley of creatures conjured up in the imagination of a young girl. This is another demonstration of airbrushing taught by Hentschel. He called his airbrush style "aquatone." In addition to teaching at the academy, he was also a designer at Cincinnati's famed Rookwood Pottery Company.

These fanciful, art school patterns were reproduced as giftwrap sixty years after their creation.

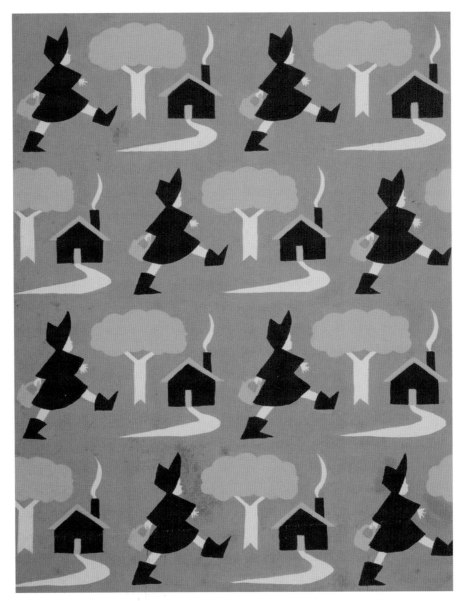

Edie McKee
Little Red Riding Hood, n.d.
Gouache on board, 12 x 9½ in.

Edie McKee
Pink Elephants, n.d.
Gouache on paper, 18½ x 12 in.

Sharon Woods was and remains a popular county park near Cincinnati in Hamilton County. Edie and Charley were wading in the creek when they were told the news of the Japanese attack on Pearl Harbor, December 7, 1941.

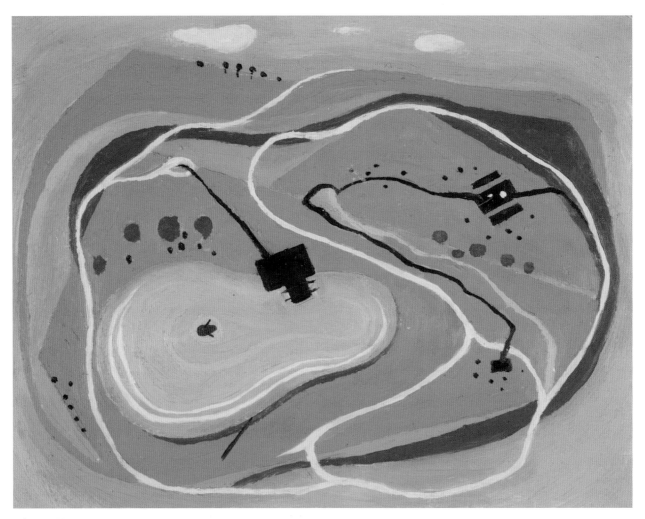

Edie McKee
Sharon Woods, Hamilton County Park, Ohio, n.d.
Oil on board, 8 x 10 in.

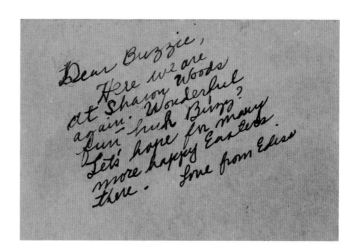

Edie and Charley often went on "working" dates as art students, and they frequently created casual works of art as gifts to each other or for class assignments. The little note from Edie refers to the county park Sharon Woods, that required a car trip, and includes one of her pet names for Charley, "Buzzie" (or "Buzzy").

Edie McKee
Aerial View of Twin Lakes, Eden Park, Cincinnati, n.d.
Oil on board, 8 x 13 in.

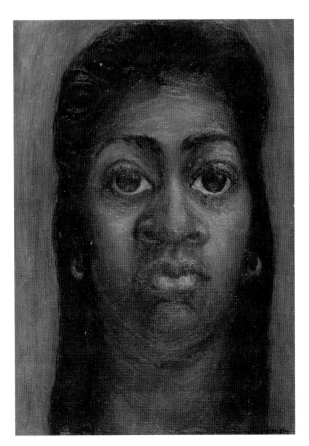

Edie McKee
Winifred, n.d.
Oil on canvas, 15 x 10 in.

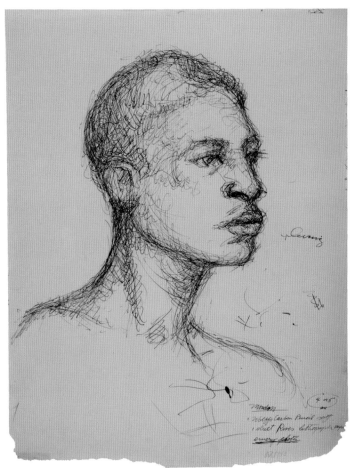

Edie McKee
Jim, n.d.
Ink on paper, 17 x 14 in.

Edie McKee
Abstract (Nude), 1944
Oil on paper, 15 x 20 in.

CHARLES HARPER — CLASS OF MR. ABEL

Charley Harper
Trio of Color Theory (Nudes), n.d.
Watercolor and ink on board and paper, 7 x 12 in.

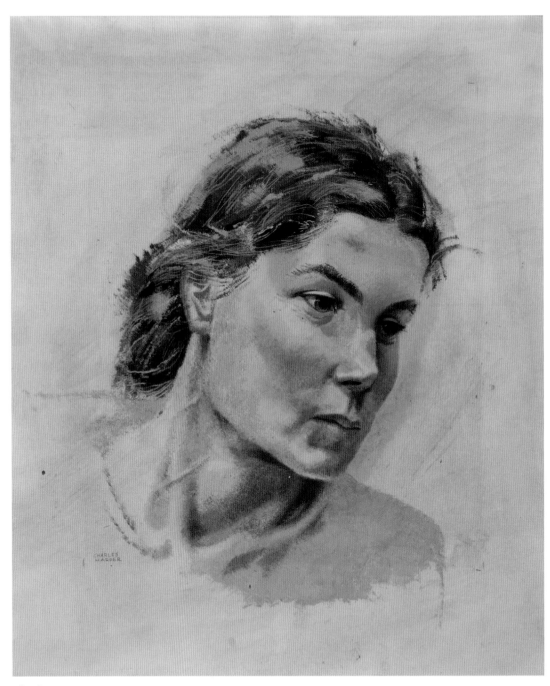

Charley Harper
Edie, n.d.
Gouache on paper, 13¼ x 10¼ in.

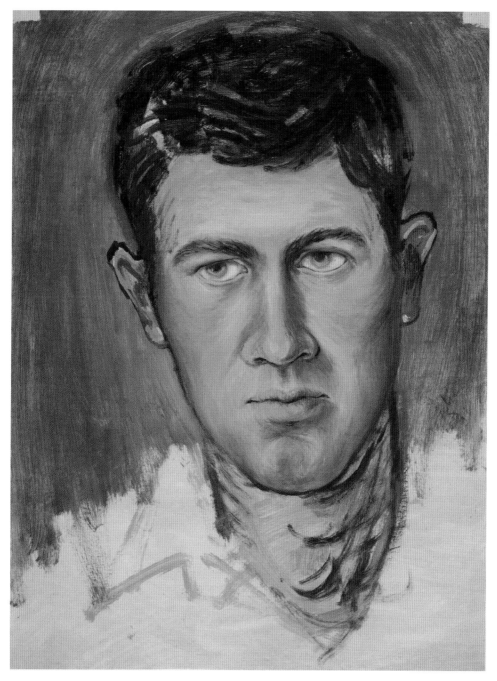

Edie McKee
Charley, n.d.
Oil on board, 17 x 13 in.

Edie McKee
Summer Night, n.d.
Oil on paper, 6 x 8 in.

Edie McKee
Mirror Lake, n.d.
Oil on board, 14½ x 19½ in.

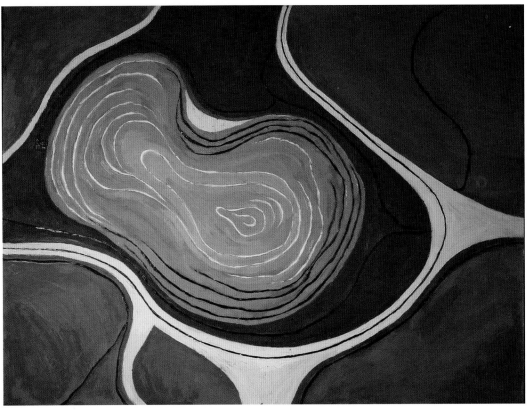

Mirror Lake is a minimalist representation that portrays a bird's-eye view of the lake at Eden Park, which overlooks the Ohio River. It was within easy walking distance of the academy.

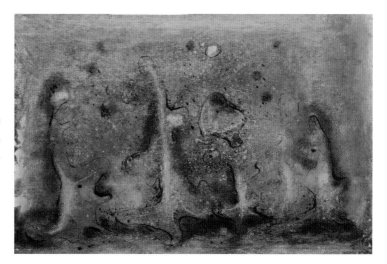

Edie McKee
Twilight, n.d.
Mixed media, 5½ x 7½ in.

Edie McKee
From Within, n.d.
Stone lithograph, 9 x 15½ in.

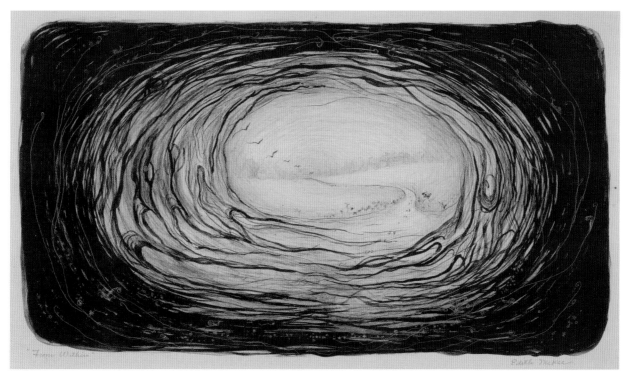

From Within is a visionary work influenced by academy printmaking instructor Maybelle Stamper. She was a pioneering feminist and symbolist artist who was part of a retrospective exhibition at the Cincinnati Art Museum in 2007.

Charley considered *Eden Park* a pivotal turning point in his evolution toward minimalism. He called it "my first nonrealistic painting."

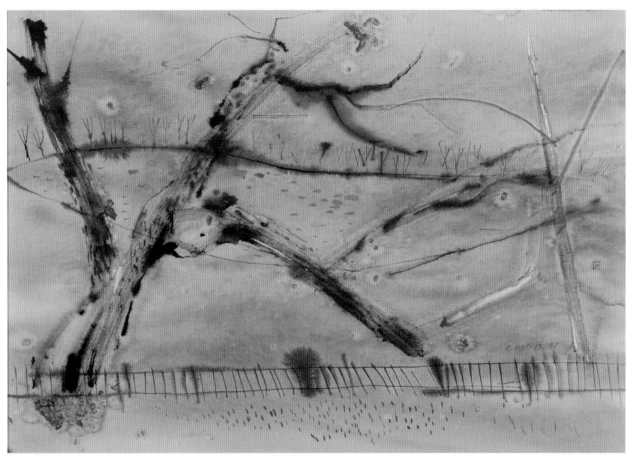

Charley Harper
Eden Park, 1947
Watercolor on paper, 12 x 18 in.

Edie McKee
Landscape, n.d.
Lithograph, 7 x 9 in.

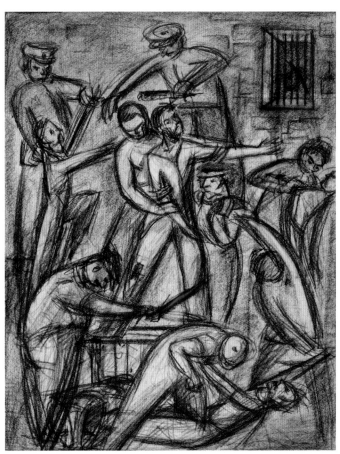

Edie McKee
Untitled, n.d.
Charcoal on paper, 22 x 17 in.

Edie McKee
Three Knights in a Bar, 1947
Graphite on paper, 7 x 5 in.

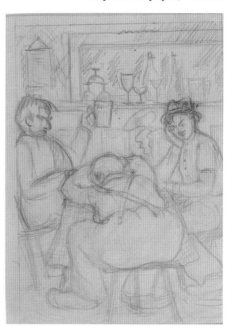

This series of three images shows the progression of *Three Knights in a Bar* from drawing to finished print.

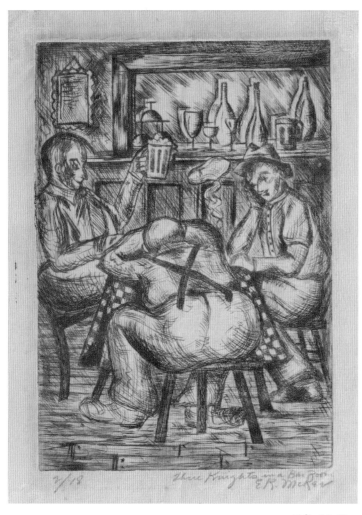

Edie McKee
Three Knights in a Bar, 1947
Etching, 8½ x 6½ in.

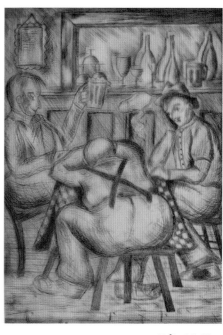

Edie McKee
Three Knights in a Bar, 1947
Etching plate, 7 x 5 in.

A whimsical drawing Charley made for Edie.

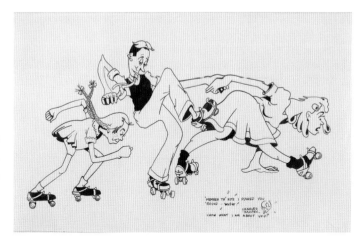

Charley Harper
Skate Date, n.d.
Ink on paper, 13 x 19½ in.

Charley Harper
Straight Line Curve (study), 1941
Graphite on paper, 12 x 18½ in.

Charley learned about this technique at the Art Academy of Cincinnati. It allowed him to simplify elements. Today, computer-aided drawing programs can accomplish what Charley used manual drafting tools for. He never used computers and, in fact, despised them.

The annual costume ball was anticipated by all of the academy art students. It was a fun evening to compete with each other for the most outlandish attire.

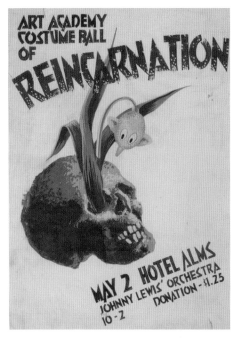

Charley Harper
Reincarnation Ball (AAC Dance Poster), 1942
Gouache on board, 16½ x 12 in.

Edie McKee
Bubbly, n.d.
Ink and gouache on paper, 17 x 11 in.

Autumn view of the family farm where Charley grew up. Once a self-sufficient operation with livestock, vegetables, and fruit trees, today the site in Frenchton, West Virginia, is largely overgrown and abandoned to the elements, but the two-story house is still inhabited.

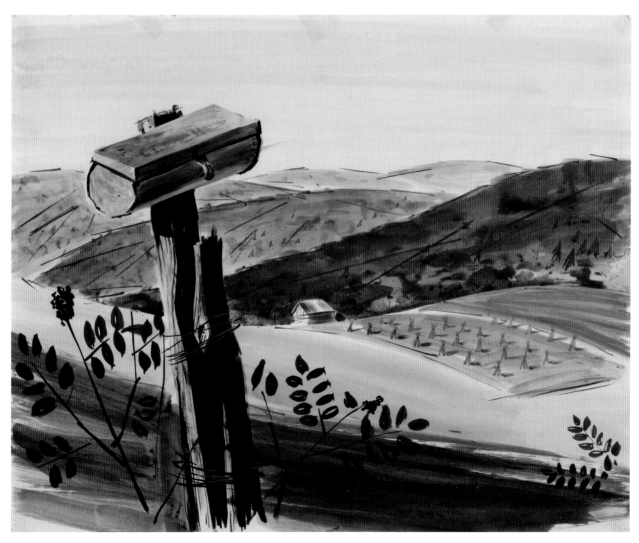

Charley Harper
Harper Farm with Mailbox #1, n.d.
Watercolor on paper, 15 x 19 in.

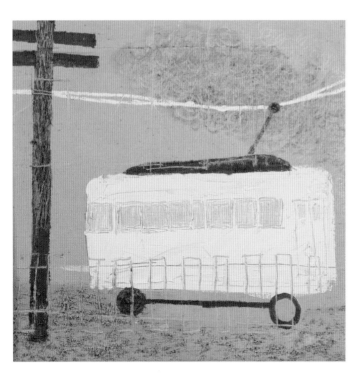

Charley Harper
Trolley, n.d.
Oil on canvas, 17 x 16 in.

Edie McKee
Street Car, n.d.
Oil on paper, 15 x 20 in.

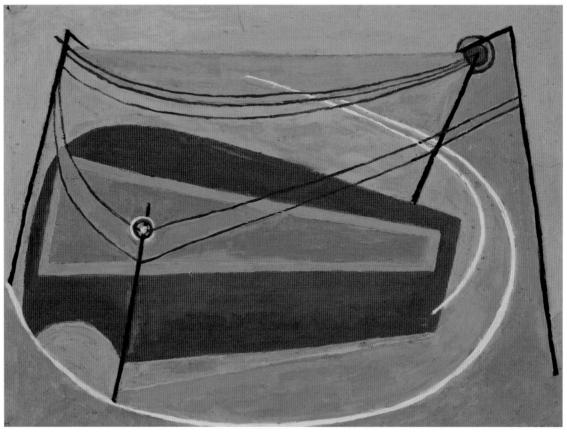

Charley Harper
Watercolor Bustle, n.d.
Watercolor on paper, 8½ x 11 in.

Edie McKee
Pink Lady with Blue Eyes, n.d.
Oil on paper, 18½ x 14¾ in.

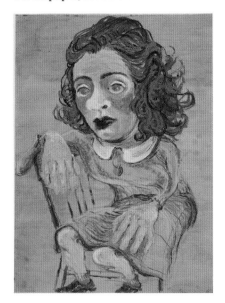

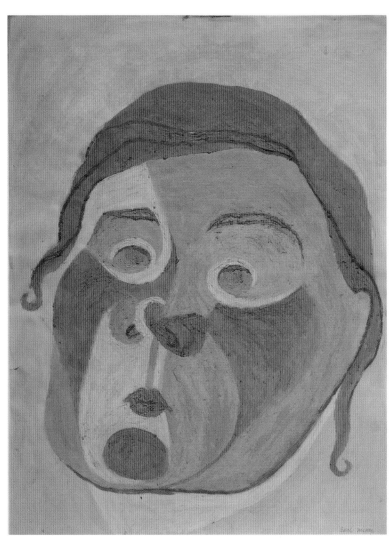

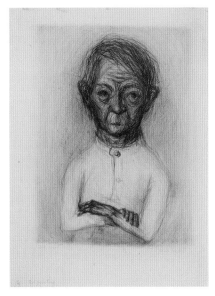

Edie Harper
Sad Man, n.d.
Lithograph, 15 x 11 in.

Edie Harper
Woman in Waiting, n.d.
Oil on paper, 20 x 15 in.

Edie McKee
Matador, n.d.
Oil on board, 20 x 15 in.

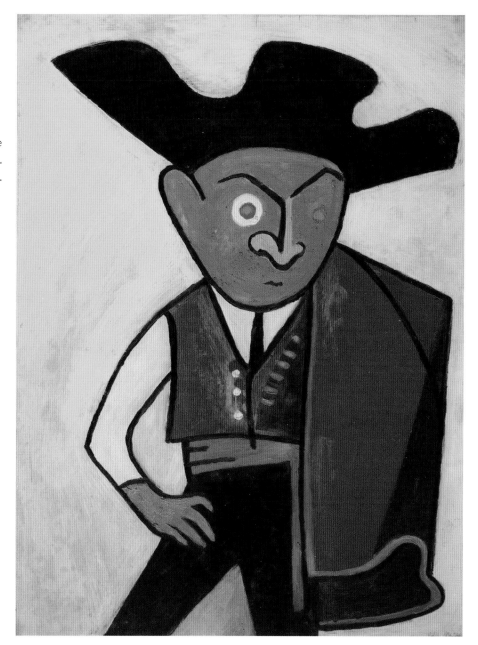

Matador was shown in 1945 at a special exhibition of select students' work, next door to the Cincinnati Art Museum.

Edie McKee
Curves Ahead Art, n.d.
Oil on board, 8½ x 11 in.

Edie McKee
Kairos (Lifetime), 1942
Acrylic and mixed media on canvas, 18 x 30 in.

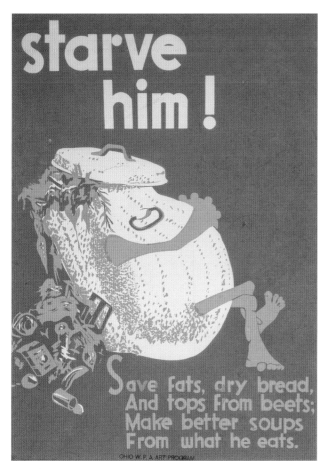

Charley Harper
Ohio WPA Art Program Poster (Green Trash Can), n.d.
Gouache on board, 18 x 13 in.

Charley Harper
Ohio WPA Art Program Poster (Yellow Trash Can), n.d.
Gouache on board, 18 x 13 in.

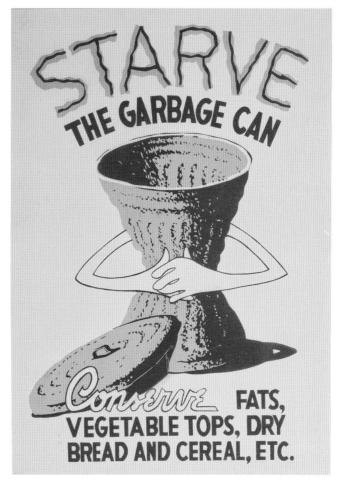

Edie McKee
Abstract (Red Eyes), 1945
Oil on board, 14 x 10½ in.

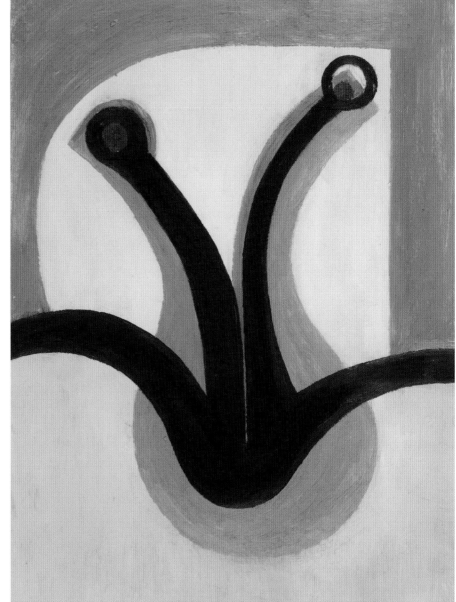

Edie McKee
Frost, 1947
Oil on board, 11 x 6 in.

The meaning of this eerie work is unknown. Are the three figures hiding behind masks or are they ghosts? Is the figure at right, holding an apple, a malevolent being or a benevolent giver?

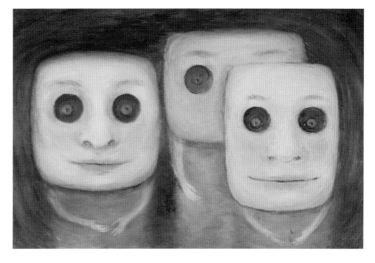

Edie McKee
Third Kind, n.d.
Oil on board, 9 x 13 in.

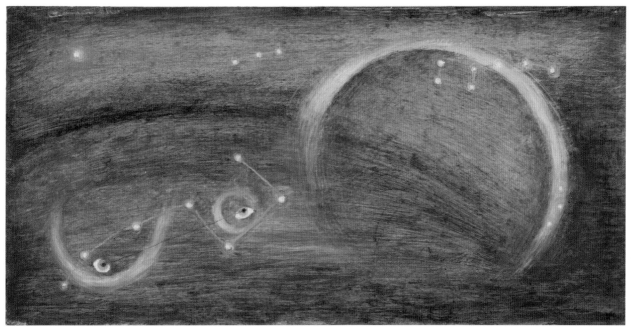

Edie McKee
Cosmos, 1947
Oil on board, 8 x 15 in.

One of several "horror" works Charley drew.

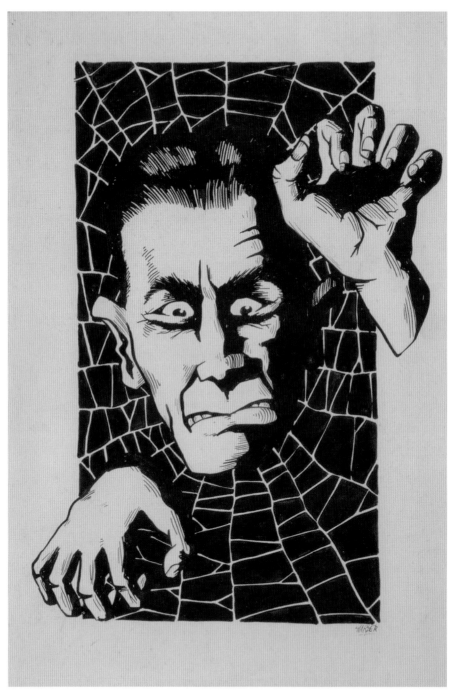

Charley Harper
Web Master, n.d.
Ink on paper, 17 x 11½ in.

Goodbye is another mystical image created under the influence of academy instructor Maybelle Stamper.

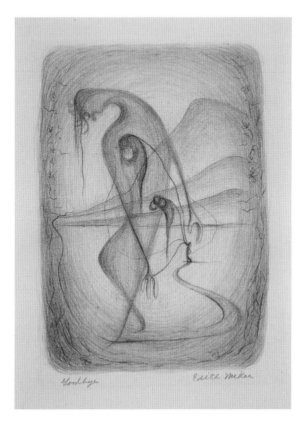

Edie McKee
Goodbye, n.d.
Stone lithograph, 10 x 7 in.

Edie McKee
Weepers, n.d.
Stone lithograph, 5½ x 5½ in.

Here is a rare collaboration between Edie and Charley. They continually critiqued each other's art throughout their working lives, but in a helpful, supportive manner.

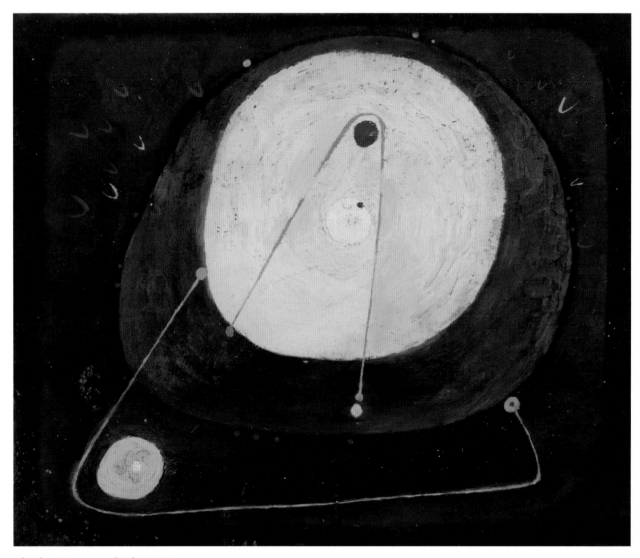

Charley Harper and Edie McKee
To the Moon and Back, 1945
Oil on board, 11 x 13 in.

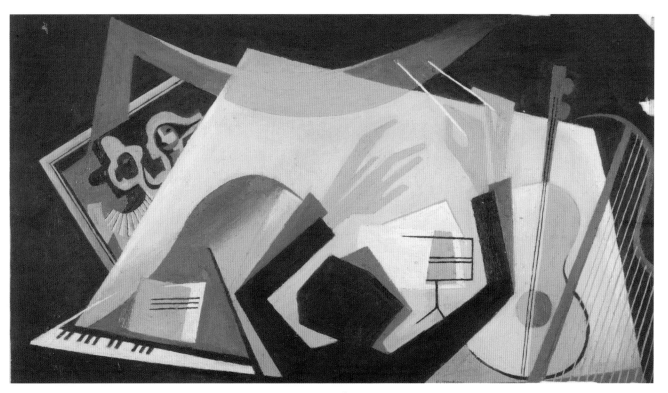

Edie McKee
Maestro, 1946
Oil on paper, 12 x 21½ in.

Charley Harper
New York Harbor, 1947
Giclée print from original pastel and gouache on cut paper, 12½ x 22 in.

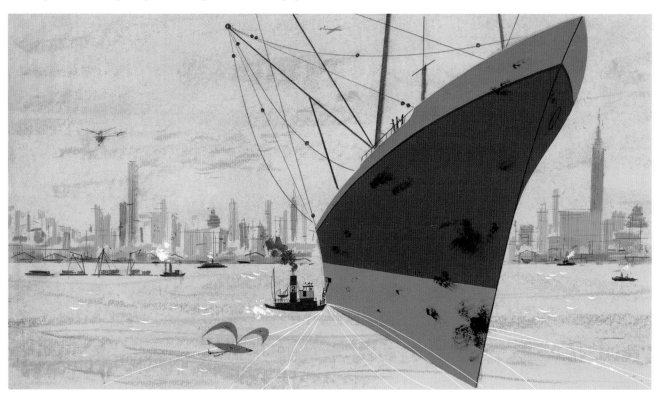

One of a handful of works conclusively attributed to Charley's brief semester enrollment at the Art Students League of New York.

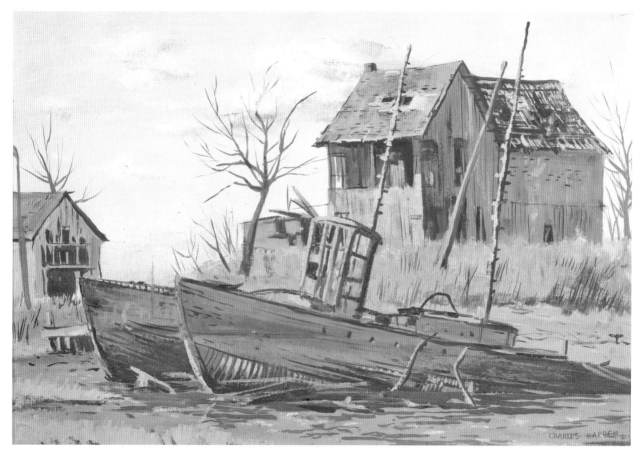

Charley Harper
Long Island Boat, 1946
Gouache on board and mixed media, 11 x 16 in.

Edie McKee
Edie's Color Wheel, 1947
Gouache on paper, 16 x 16 in.

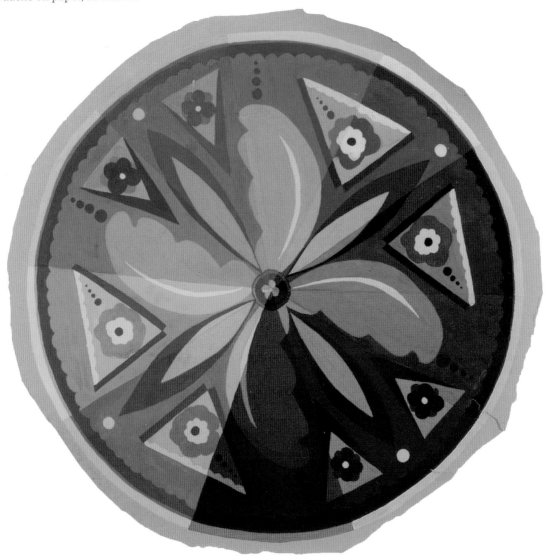

It is probable that Edie created *Edie's Color Wheel* as a tool to assist her in mixing colors. In the 1950s, she personally mixed all of the oil-based paints Charley employed in printing his hand-pulled serigraphs of images appearing in *Ford Times* magazine.

This work, long forgotten, came back into the possession of the Charley and Edie Harper Art Studio in the early 2000s. It was purchased at a modernism show and donated to the studio by Dudley Fisher.

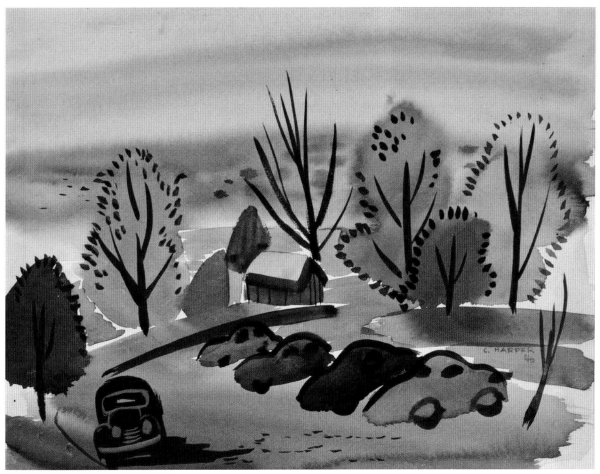

Charley Harper
Autumn, 1946
Watercolor on paper, 9 x 12 in.

Edie portrays herself here as a child.

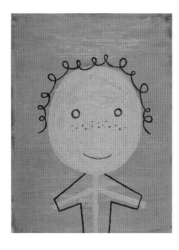

Edie Harper
Edie Self-Portrait, 1947
Oil on board, 14½ x 11 in.

In this intensely personal narrative, Edie looks back at her childhood from her twenty-fifth birthday.

Edie Harper
Birthday, 1947
Oil on canvas, 15½ x 25½ in.

Charley's portrait of a fellow Art Academy of Cincinnati student.

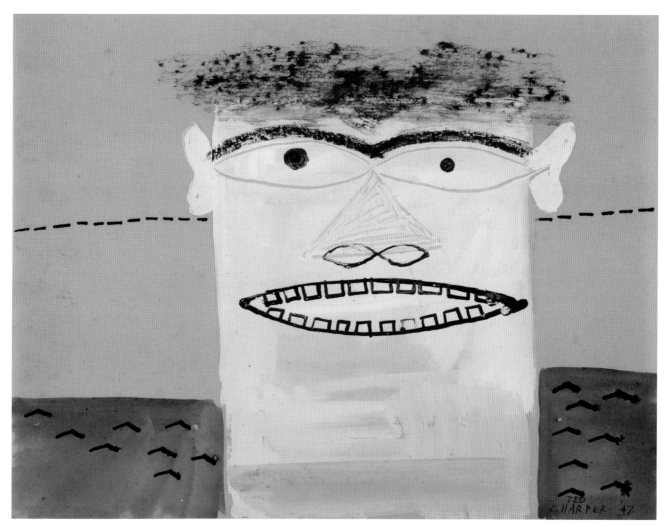

Charley Harper
Ted (an academy friend), 1947
Watercolor on paper, 8½ x 10 in.

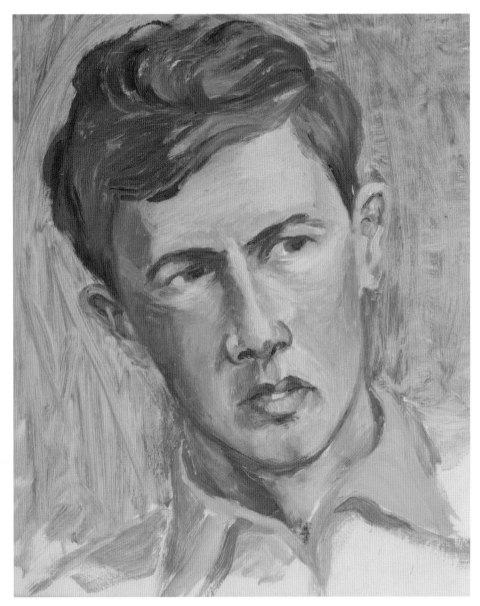

Edie McKee
Charley, n.d.
Oil on board, 16½ x 13½ in.

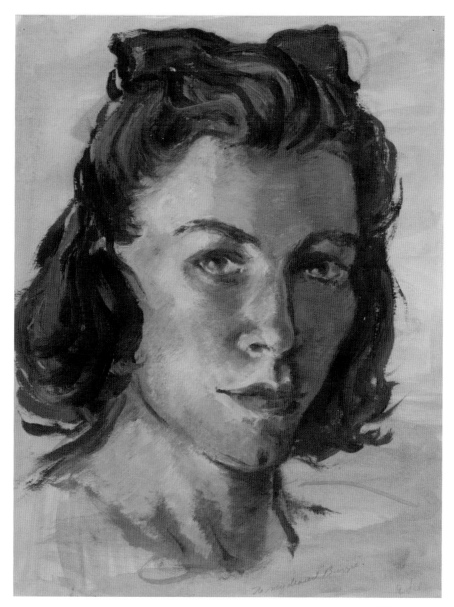

Edie Harper
Self-Portrait, 1947
Gouache and watercolor on paper, 15 x 12 in.

War Years 1942–1945

Charley Harper
Charley Harper Self-Portrait (as a soldier), 1944–1945
Oil on canvas, 20 x 16 in.

Charley Harper
Red Cross (study), 1944
Gouache on board, 3½ x 2½ in.

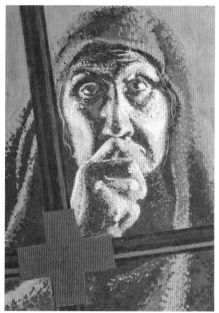

Charley Harper
Red Cross, 1944
Gouache on board, 19½ x 13½ in.

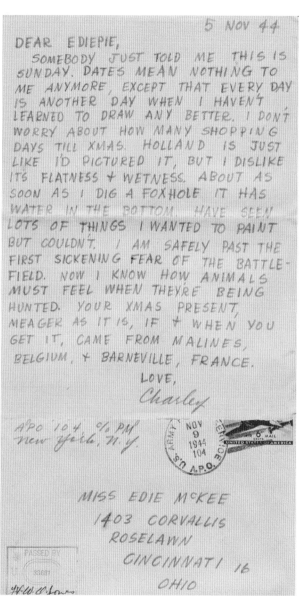

5 NOV 44

DEAR EDIEPIE,
 SOMEBODY JUST TOLD ME THIS IS
SUNDAY. DATES MEAN NOTHING TO
ME ANYMORE, EXCEPT THAT EVERY DAY
IS ANOTHER DAY WHEN I HAVEN'T
LEARNED TO DRAW ANY BETTER. I DON'T
WORRY ABOUT HOW MANY SHOPPING
DAYS TILL XMAS. HOLLAND IS JUST
LIKE I'D PICTURED IT, BUT I DISLIKE
ITS FLATNESS + WETNESS. ABOUT AS
SOON AS I DIG A FOXHOLE IT HAS
WATER IN THE BOTTOM. HAVE SEEN
LOTS OF THINGS I WANTED TO PAINT
BUT COULDN'T. I AM SAFELY PAST THE
FIRST SICKENING FEAR OF THE BATTLE-
FIELD. NOW I KNOW HOW ANIMALS
MUST FEEL WHEN THEY'RE BEING
HUNTED. YOUR XMAS PRESENT,
MEAGER AS IT IS, IF + WHEN YOU
GET IT, CAME FROM MALINES,
BELGIUM, + BARNEVILLE, FRANCE.
 LOVE,
 Charley

APO 104 % PM
New York, N.Y.

MISS EDIE McKEE
1403 CORVALLIS
ROSELAWN
 CINCINNATI 16
 OHIO

Charley Harper
Helmet Combat (Camp Carson, Colorado), 1945
Ink on paper, 9½ x 12 in

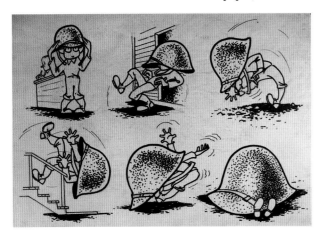

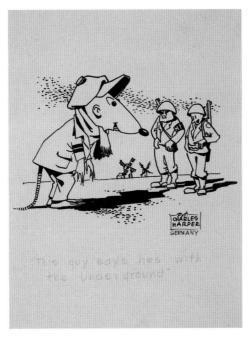

Charley Harper
He's with the Underground, 1944
Ink on paper, 9 x 7 in.

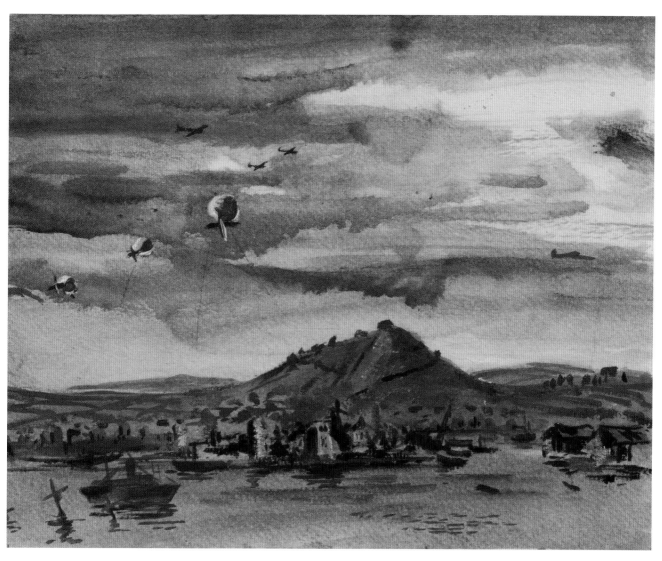

Charley Harper
Securing the Beach, 1944–1945
Watercolor on paper, 8 x 10 in.

Charley Harper
Birgel, Germany, 1944–1945
Watercolor on paper, 9 x 12 in.

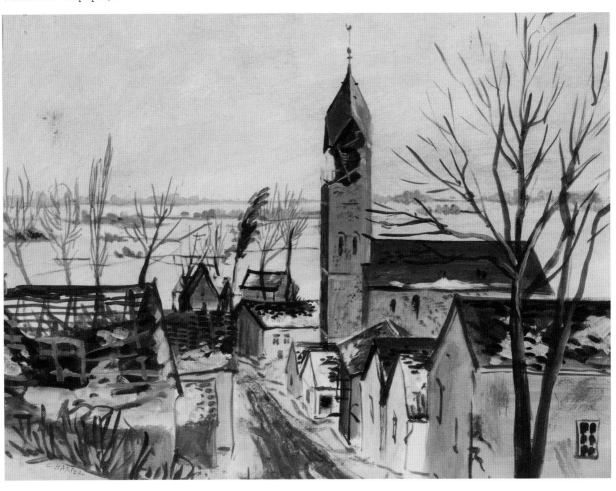

Charley Harper
Duren, Germany, 1945
Watercolor on paper, 7 x 9 in.

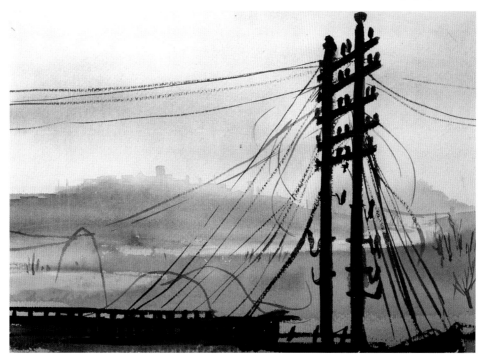

Charley Harper
Cologne, Germany (Dom Cathedral), 1945
Gouache on paper, 7 x 9½ in.

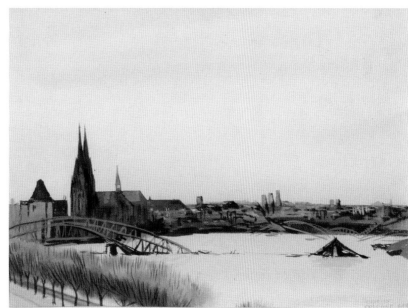

Charley Harper
Attack on Eschweiler, 1944, 1944–1945
Gouache on board, 5 x 7 in.
Cover of *Infantry Journal*, 1946

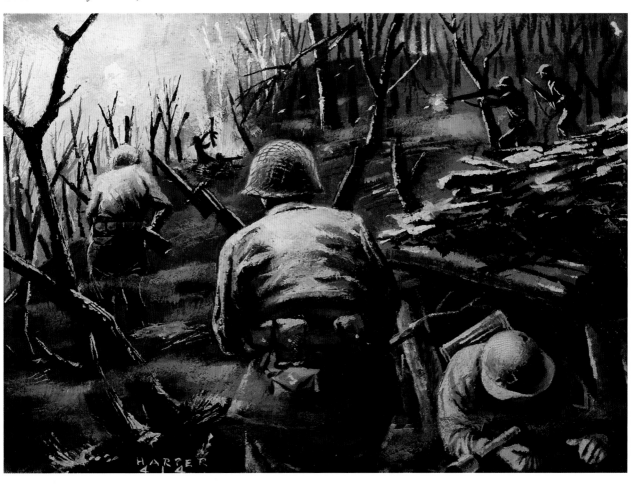

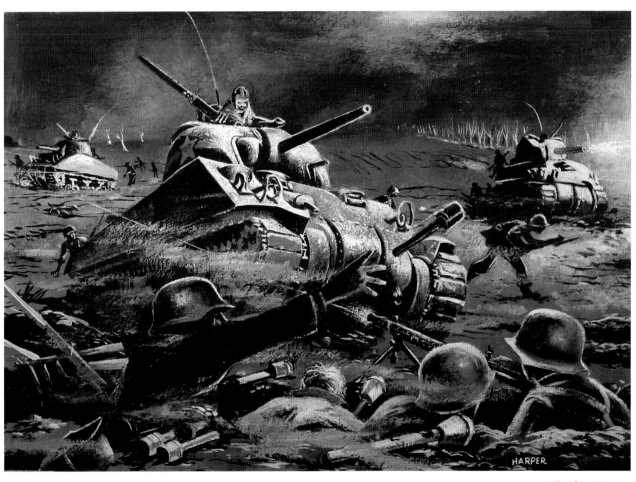

Charley Harper
Phase VI Spearhead (Tank), 1944–1945
Watercolor and gouache on paper, 5 x 7 in.

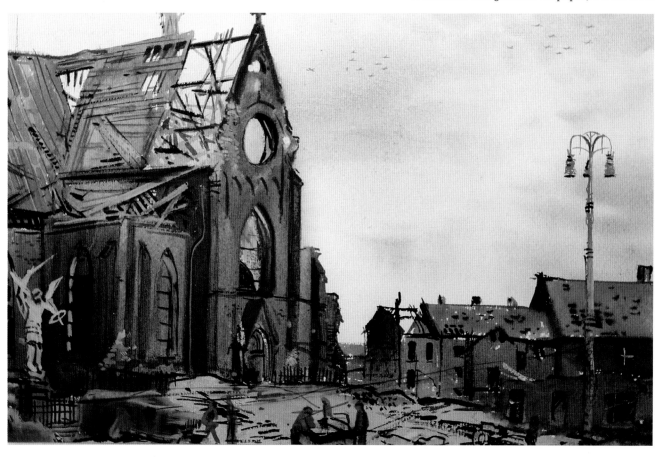

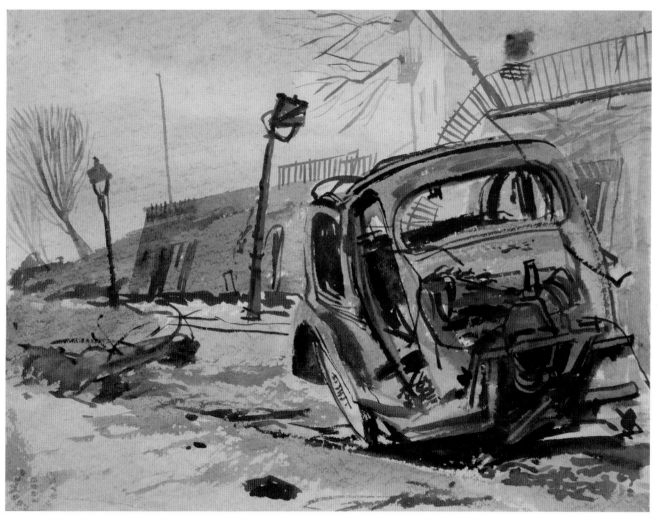

Charley Harper
Bombed Out Car, 1944–1945
Watercolor on paper, 9 x 12 in.

Charley Harper
Bombed Out Tank (Schevenhutte, Germany), January 6, 1945
Ink on paper, 9 x12 in.

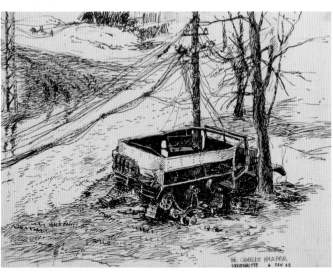

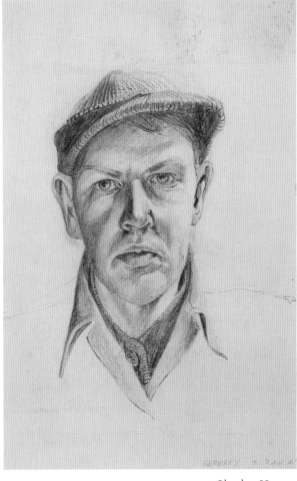

Charley Harper
Charley Self-Portrait, January 7, 1945
Graphite on paper, 12 x 9 in.

11 Jan 45

Dear Edie,

If you haven't heard from me for some time it's because I've been busier than usual, doing something every minute of which I have enjoyed: I've been doing illustrations for a short history of my division which the Public Relations Office is writing. I've worked three days now and finished four drawings. I'm sorry the job is done because it isn't every day I get to devote all my attention to drawing, in a warm office and sitting beside a radio. Heard my fill of symphony music and a lot of silly German propaganda like this gem: after proclaiming in mournful voice that all meat stores in New York City had been closed the guy told the old one about FDR's promising that "your boys will never go overseas" then played "It's a Sin to Tell a Lie." What they don't seem to know is that we think their programs are funny. Uncle made me a present this week of a brand new sleeping bag (sleeping bag? no, just dozing). I just crawl in, run the zipper to the top, and stick my nose out the hole that's left. It's wonderful. And came just in time--this place is downright frigid at present. Hope I can send you one of the books I illustrated--it'll tell you every place I've been and give you an idea of some of the experiences I couldn't describe in my letters.

Love,
Charley

Charley Harper
"Jeepers," 1944–1945
Ink on paper, 10 x 7 in.

Charley Harper
When's That Relief Coming?, 1945
Ink on paper, 9½ x 7½ in.

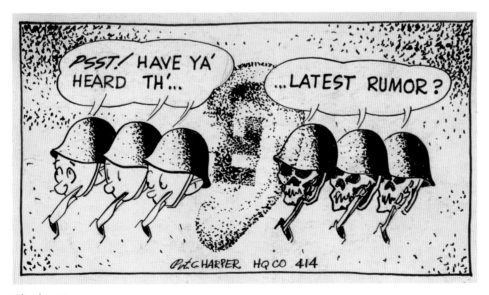

Charley Harper
Loose Lips (Have You Heard the Rumor), 1944–1945
Ink on paper, 6 x 9 in.

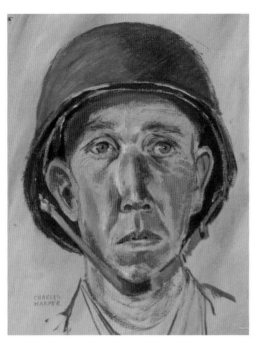

Charley Harper
Army Buddy, 1944–1945
Watercolor and gouache on paper, 11¼ x 8¾ in.

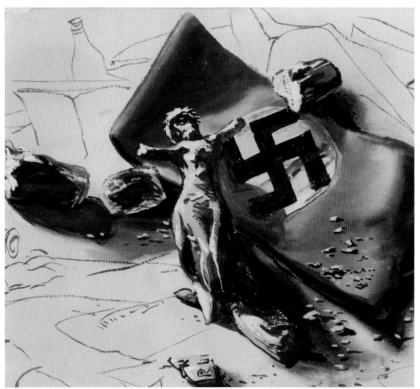

Charley Harper
Nazi Arm Band and Broken Crucifix (Birgel), 1945
Gouache, watercolor, and graphite on paper, 8 x 9 in.

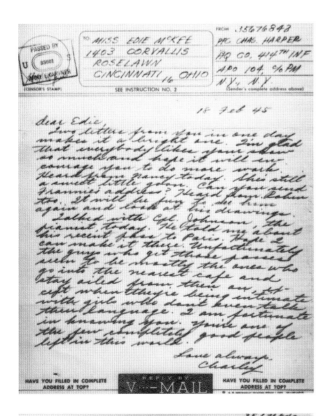

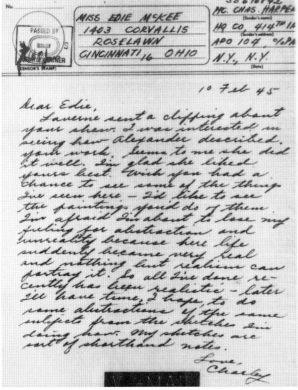

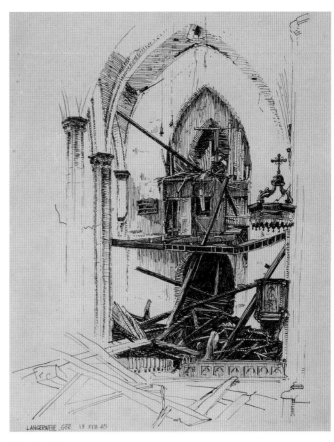

Charley Harper
Bombed Out Church (Langerwehe, Germany),
February 19, 1945
Ink on paper, 16 x 12 in.

Charley Harper
Langerwehe, Germany, 1945
Watercolor and gouache on paper, 12½ x 15¼ in.

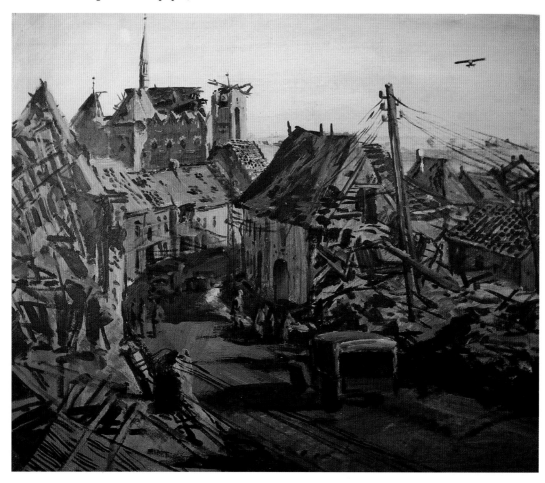

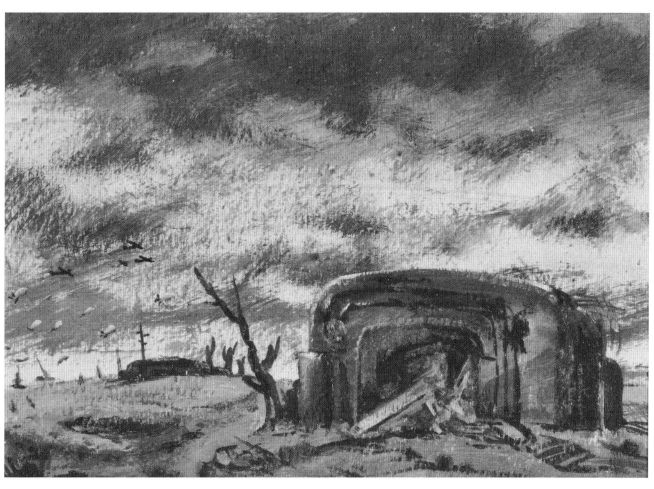

Charley Harper
Teutschenthal, Germany, 1944–1945
Watercolor and gouache on paper, 7 x 10 in.

Charley Harper
The Last Words, 1944–1945
Watercolor and gouache on paper, 6 x 9 in.

Charley Harper
Night's Mantle Concealed Them, 1944–1945
Gouache and ink on paper, 7 x 10 in.

Charley Harper
War Stories (Hole in Helmet), 1945
Gouache on board, 8 x 9½ in.

Honeymoon 1947

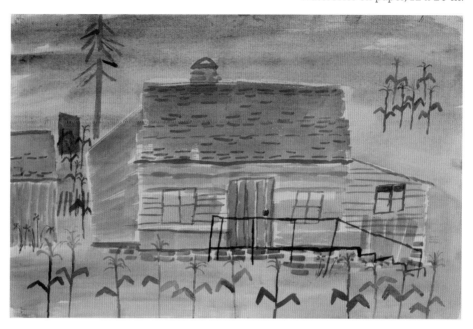

Edie Harper
Kansas, 1947
Watercolor on paper, 12 x 20 in.

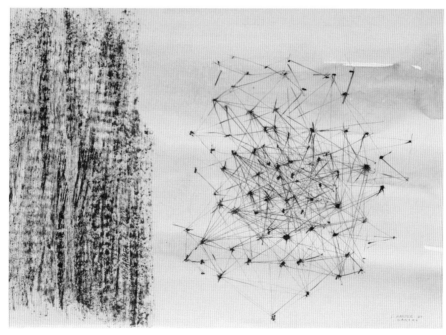

Charley Harper
Kansas (Swarm of Gnats), 1947
Watercolor on paper, 12 x 16½ in.

Edie Harper
Sunflower, 1947
Oil on board, 19 x 12 in.

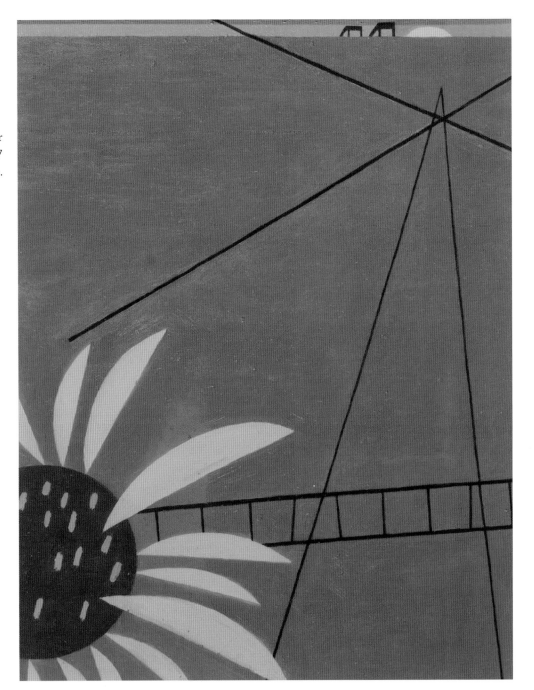

Sunflower was probably painted in Kansas or Nebraska on their honeymoon, while visiting relatives.

Charley gave this painting to the academy upon his return from his honeymoon. As a condition of receiving the first Stephen H. Wilder Traveling Scholarship, he was required to gift the school with one of the works that he created during his travels.

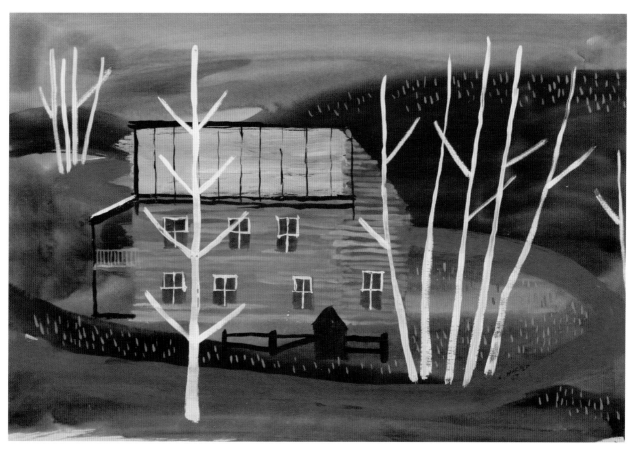

Charley Harper
Landscape with Yellow Home, 1947
Watercolor on paper, 12 x 16 in.

Edie Harper
Ozarks, 1947
Watercolor on paper, 12 x 18 in.

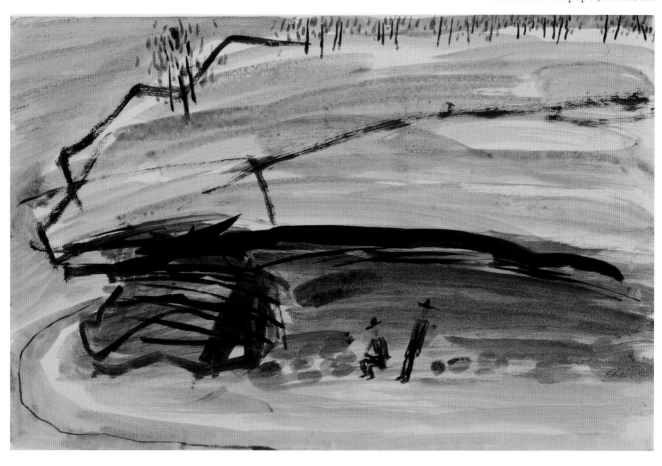

One of several works Charley produced in accordance with his growing belief that vast landscapes required simplification. Only in this way, he became convinced, could the magnitude and grandeur of what he saw be conveyed.

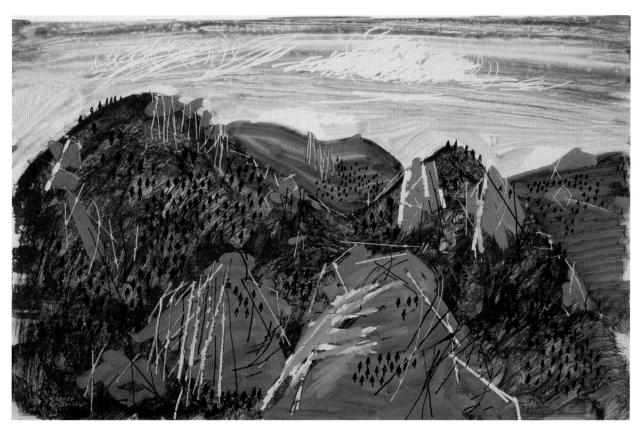

Charley Harper
Rocky Mountain near Pike's Peak, 1947
Gouache on board, 13 x 21 in.

Edie Harper
Rocky Mountains, 1947
Watercolor on paper, 11 x 17 in.

Charley Harper
Honeymoon Oregon Coast, 1947
Watercolor on paper, 12 x 19 in.

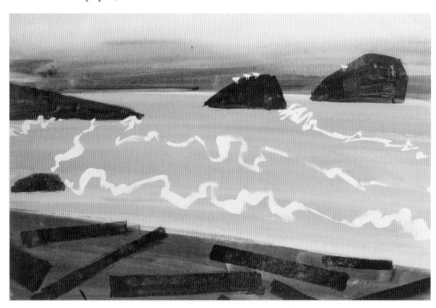

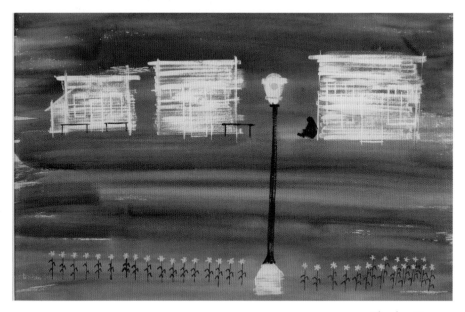

Charley Harper
Honeymoon Streetlight and Flowers, 1947
Watercolor on paper, 12 x 19¼ in.

Charley Harper
Honeymoon Rocky Stream, 1947
Watercolor on paper, 12 x 18½ in.

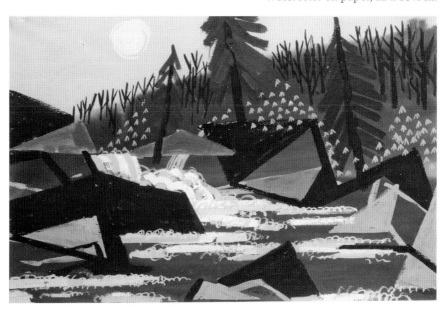

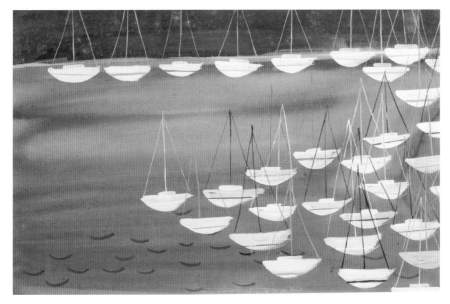

Charley Harper
Honeymoon Boats in Harbor, 1947
Watercolor on paper, 12 x 18½ in.

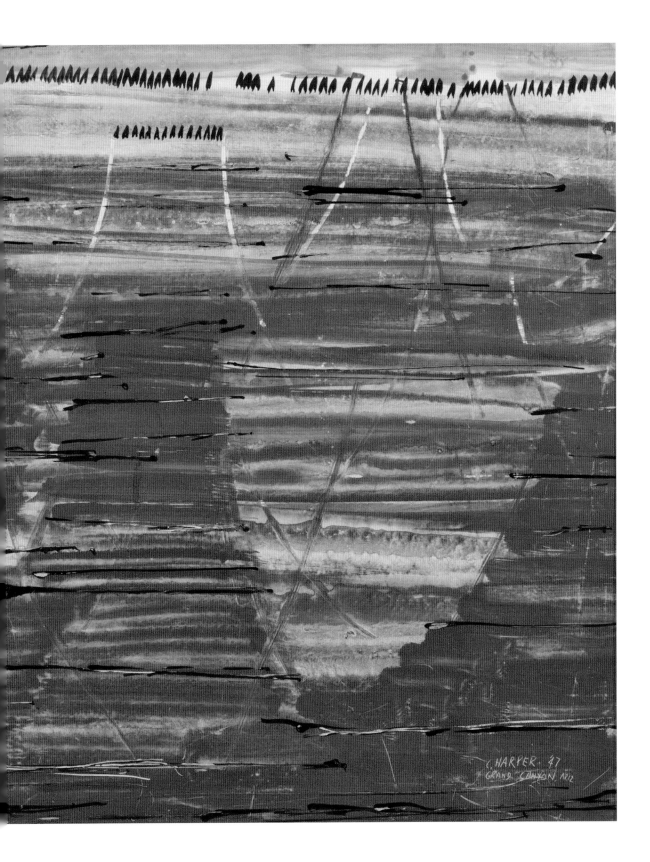

C. HARPER. 47
GRAND CANYON Nº12

PREVIOUS: Charley Harper
Grand Canyon #1, 1947
Watercolor on scratchboard, 13 x 21½ in.

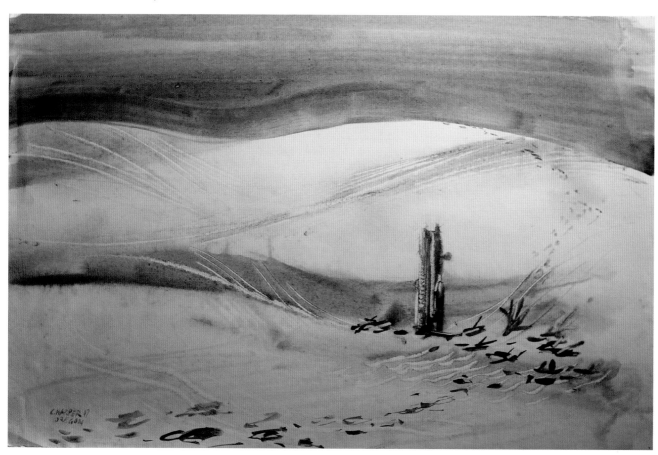

Charley Harper
Oregon Dunes, 1947
Watercolor on paper, 12 x 19 in.

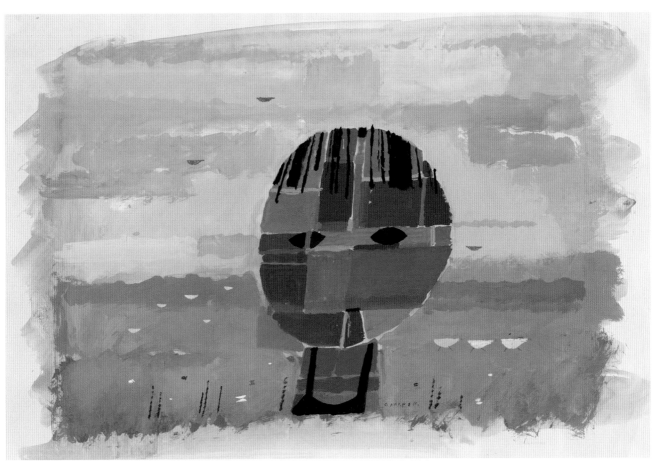

Charley Harper
Beach Day Dreaming, 1947
Gouache and mixed media on paper, 14½ x 20½ in.

Charley Harper
Captiva Island Bird, 1947
Gouache and mixed media on paper, 12 x 18½ in.

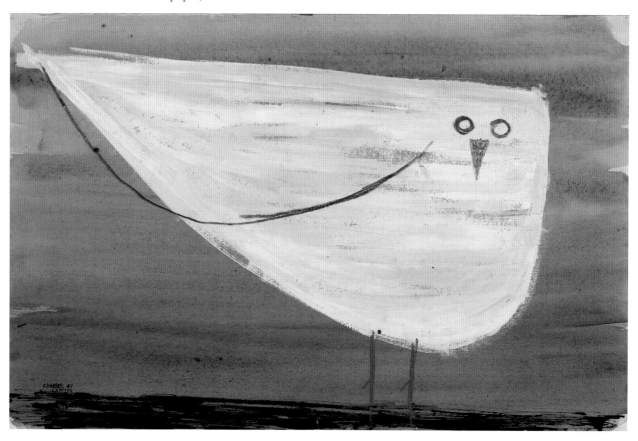

Charley identified *Captiva Island Bird* as his first bird painting.

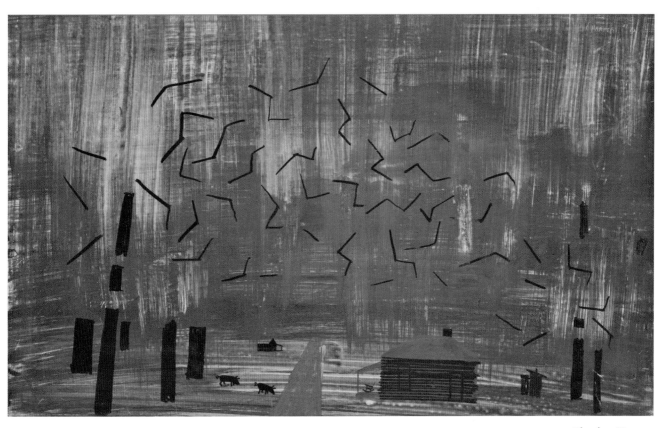

Charley Harper
In Louisiana, 1947
Gouache on board, 13¼ x 22 in.

Beginning of Ever After

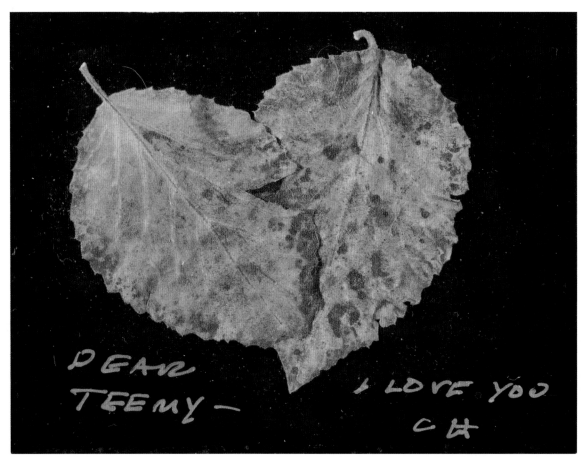

Charley Harper
To Teemy, Love Charley Harper, n.d.
Leaves and silver marker on Kromekote paper, 4 x 5½ in.

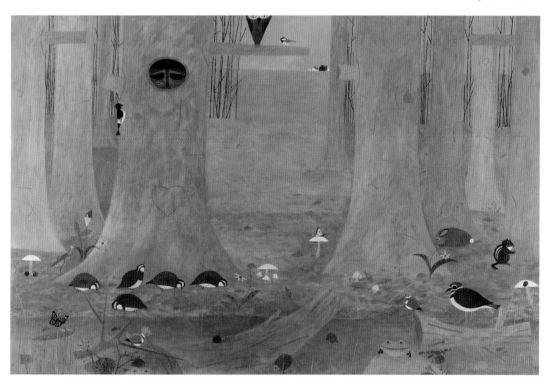

Edie Harper
Woodland Fauna, 1948
Oil on canvas, 48¼ x 72⅛

Edie Harper
Class, n.d.
Oil on canvas, 19 x 36 in.

Charley Harper
Cowboy Cookies, 1950
Gouache on paper, 13¼ x 19½ in.

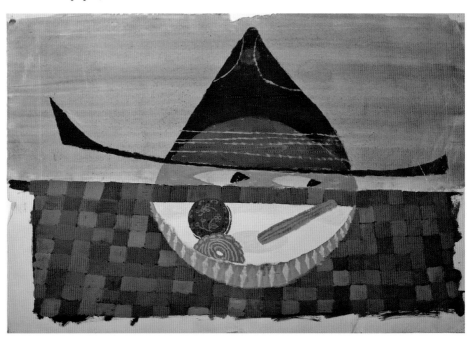

Edie Harper
Through Kentucky, early 1950s
Oil on board, 12 x 22 in.

In 1948, Charley was hired as an illustrator for Studio Art in downtown Cincinnati. There he learned all of the commercial art skills he would apply later to his own work.

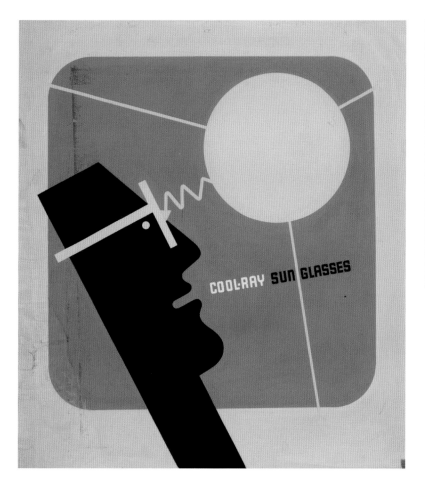

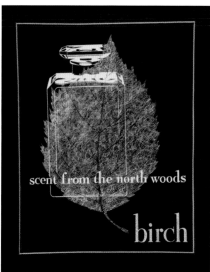

Charley Harper
Birchwood Ad, early 1950s
Gouache and ink with scratch work,
10 x 8 in.

Charley Harper
Cool Ray Sunglasses, early 1950s
Gouache on board, 19 x 18 in.

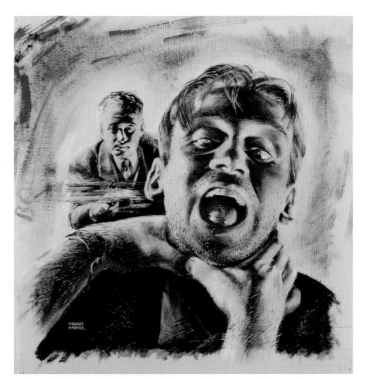

Charley Harper
Crime, 1951
Gouache on board, 12 x 12 in.

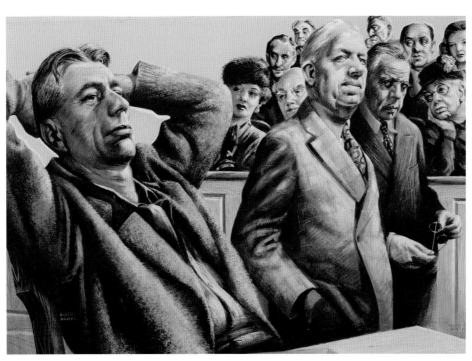

Charley Harper
I Rest My Case, 1951
Gouache on board, 15 x 21 in.

Charley Harper
Art Supplies: Studio Art #1, 1951
Ink and graphite on paper, 12 x 16 in.

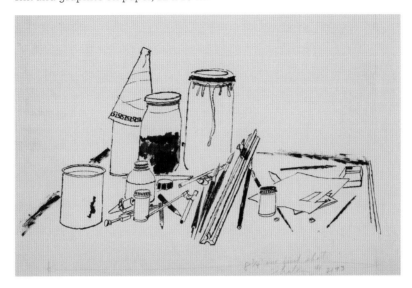

Charley Harper
Art Supplies: Studio Art #2, 1951
Gouache on paper, 11 x 19 in.

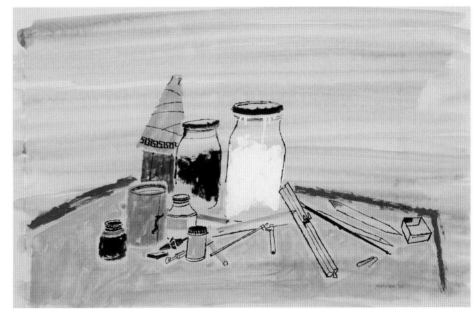

The typical equipment of a "board" artist of the 1950s and 1960s. In those years, and until the advent of computers, artists prepared overlays and instructions for color separators and printers.

On the Porch was inspired by Charley's memories of growing up in West Virginia.

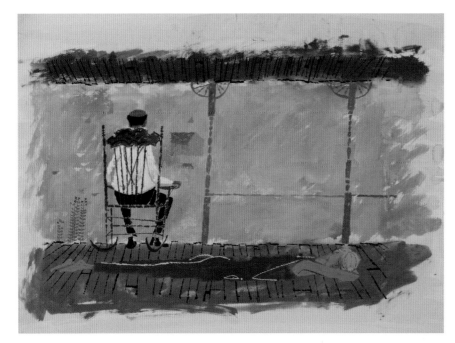

Charley Harper
On the Porch, 1951
Gouache on paper, 14 x 20 in.

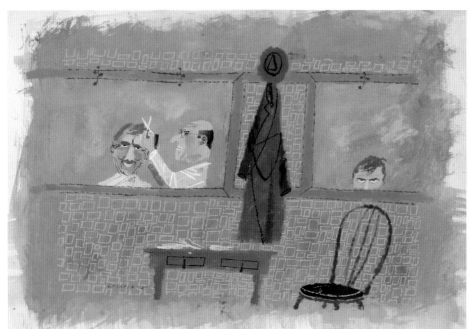

Charley Harper
Barber Shop, 1951
Gouache on paper, 14½ x 20 in.

Rarely has getting a simple haircut appeared so grim.

Edie and Charley produced many fine illustrations for Rosenthal Publishing's *Writer's Digest*.

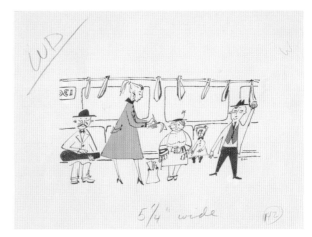

Edie Harper
Next Stop: Writer's Digest, 1950s
Ink on paper, 14 x 23 in.

Charley Harper
On the Fly, 1950s
Cut paper and gouache on board, 13¾ x 23¼ in.

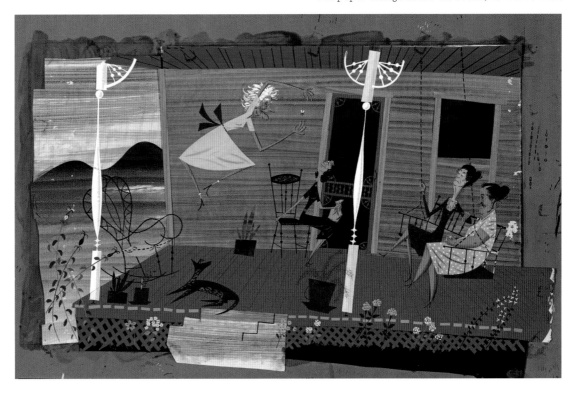

This whimsical painting is based on the familiar verse "There Was An Old Lady Who Swallowed A Fly."

With this important milestone, Charley captured the immensity of the Grand Canyon in an approach he would much later describe as "minimal realism." Note the Ford Model T and couple in turn-of-the-century attire. This image was one of many destination paintings Ford Motor Company commissioned Charley to produce as an artist-for-hire. The idea was to sell more cars by romanticizing the places car buyers could drive.

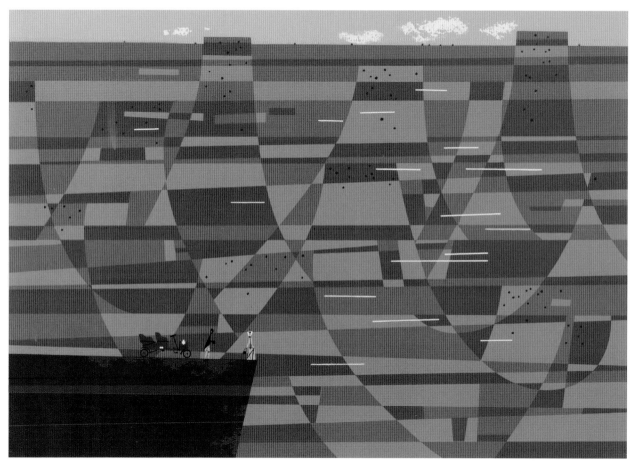

Charley Harper
Grand Canyon #2, 1952
Serigraph, 13 x 18¼ in.

Charley Harper
Mammoth Cave, 1953
Cut paper and gouache on illustration board, 13 x 18 in.

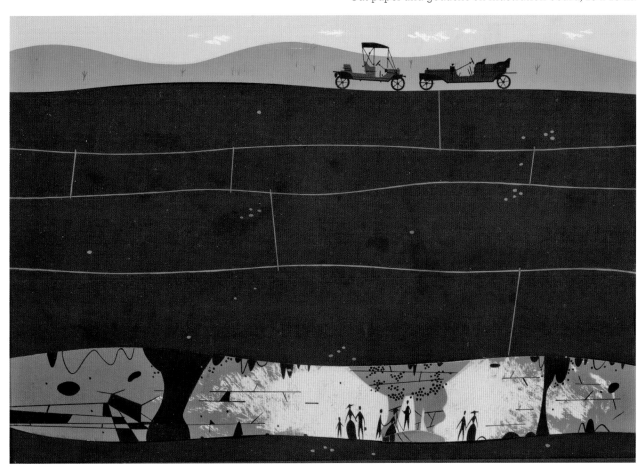

Another image from *Ford Times* magazine, one of the great showcases and repositories of illustration before photography became the dominant art form in automobile advertising and promotion. This work pictures a documented tradition, the conducting of weddings in the underground chambers of Mammoth Cave National Park, Kentucky.

All three variations of *Experiment* were produced on Bavarian limestone in the "Palmetto House," the beach hut where Maybelle Stamper lived. In the latter two variations, Charley seems to be outlining the shape of an ocean fish, perhaps a flounder. Only about six impressions of each variation of *Experiment* were made.

Charley Harper
Experiment (variation #2), 1951
Stone lithograph, 13 x 10 in.

Charley Harper
Experiment (variation #3), 1951
Stone lithograph, 13 x 10 in.

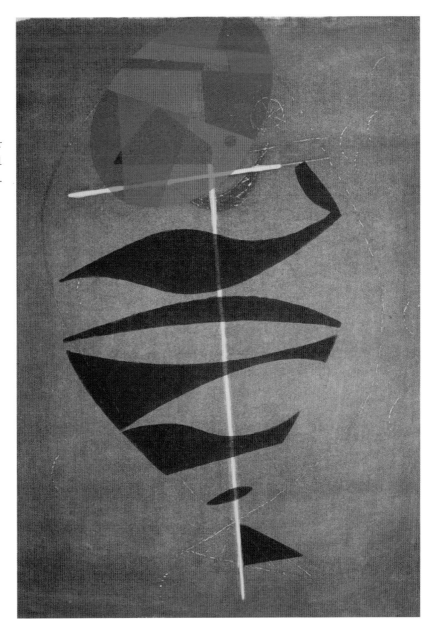

Charley Harper
Experiment (variation #1), 1951
Stone lithograph, 13 x 10 in.

Maybelle Stamper squatted on the beachfront of Captiva Island, Florida, in her hideaway called "Palmetto House." In exchange for food and other necessities, she traded artwork. On days when she welcomed visitors, she put out a sign noting she was "In." Edie and Charley visited Stamper during their 1947 honeymoon and again in 1951, when Charley produced these three stone lithographs.

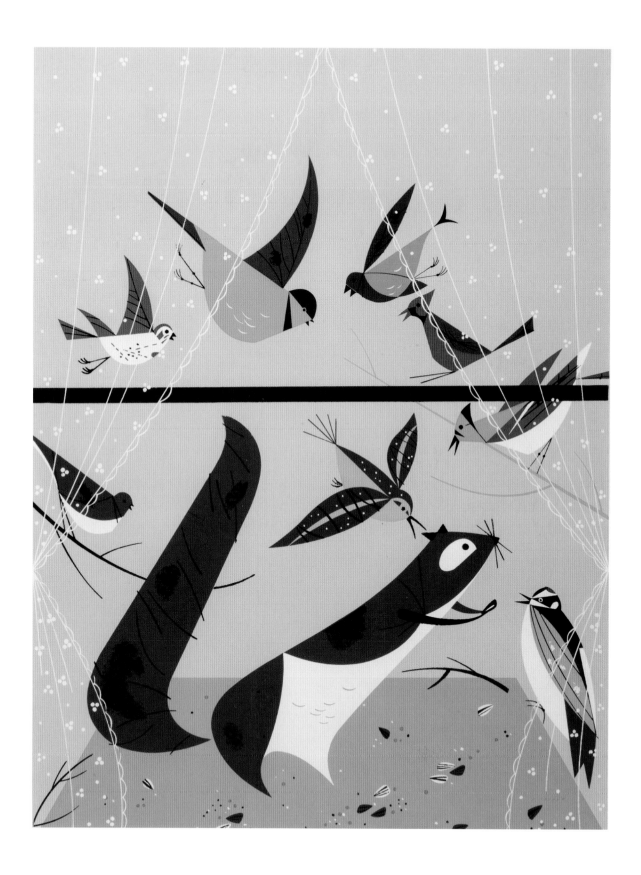

The art director of *Ford Times* magazine, Arthur Lougee, asked Charley to paint a bird feeding station. Charley asked, "What's that? Back where I come from in West Virginia, the birds are able to feed themselves!" After Lougee sent Charley a sample feeding station in the mail, he positioned it outside of his mother's living room in Buckhannon, West Virginia, beyond the window's lacey curtains. A bit cartoonish-looking here, by 1955, only a year later, his birds would appear much more sophisticated. His style would gel. He would never regress or backtrack.

Charley Harper
Feeding Station, 1954
Serigraph, 18¼ x 13 in.
Cover of *Ford Times* magazine, November 1954

At age three, I could not resist assisting my father in this depiction of a towhee. Charley titled the work, *By Brett and Daddy.*

Charley Harper and Brett Harper,
Towhee (By Brett and Daddy), 1956
Cut paper and gouache on illustration board, 13 x 18 in.

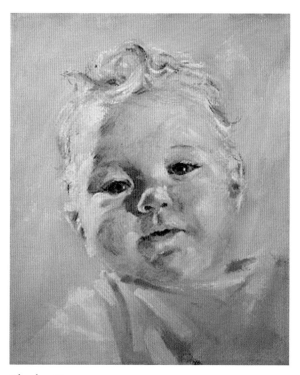

Charley Harper
Portrait of Brett, 1955
Oil on canvas, 9 x 11 in.

Charley painted realistically whenever he needed to. During his twenty-year stint teaching at the academy, he stressed to his students the importance of learning to draw and paint realistically before they tried to manipulate or alter their subjects.

An array of *Moonbeams* covers designed by Charley. *Moonbeams* was the corporate magazine of Procter & Gamble in Cincinnati. The designs won award after award from the Cincinnati Art Directors Club.

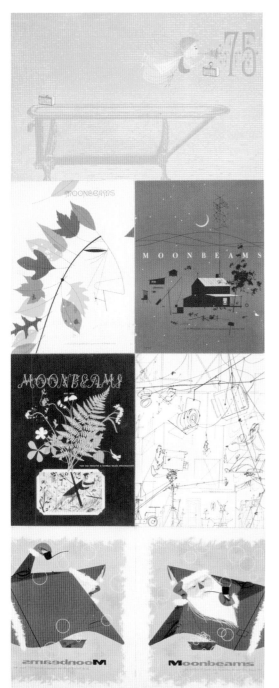

Charley Harper
Moonbeams Collage, 1954–1956
Collage of magazine covers, 48 x 26 in.

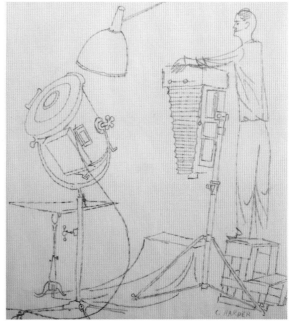

Charley Harper
Lights, Camera, Harper, 1954
Ink on paper, 9 x 8 in.

Edie Harper
Silver Springs, Florida, 1950s
Cut paper and gouache on board, 11 x 15½ in.

Edie's commentary on conformity, conveyed through birds.

Edie Harper
The Different One, 1950
Oil on canvas, 26½ x 30 in.

Edie was a skilled loom weaver as well as painter, enamelist, photographer, sculptor, and printmaker.

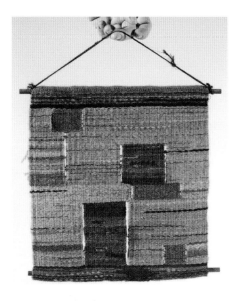

Edie Harper
Woven Homes, n.d.
Woven wool, 12 x 13 in.

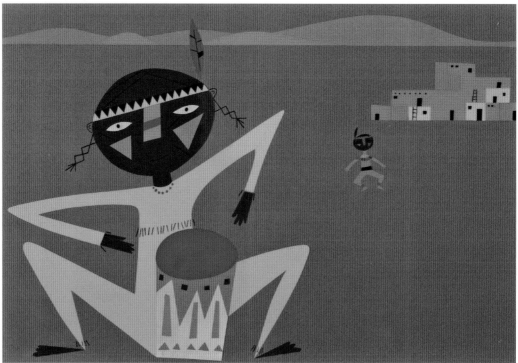

Edie Harper
Indian Drummer, 1950s
Cut paper and gouache on board, 10½ x 15 in.

At night looking east toward the Harper home. The studio, attached by a boardwalk, is behind the house in this view. The house and studio were designed and built in 1958 by Rudy Hermes.

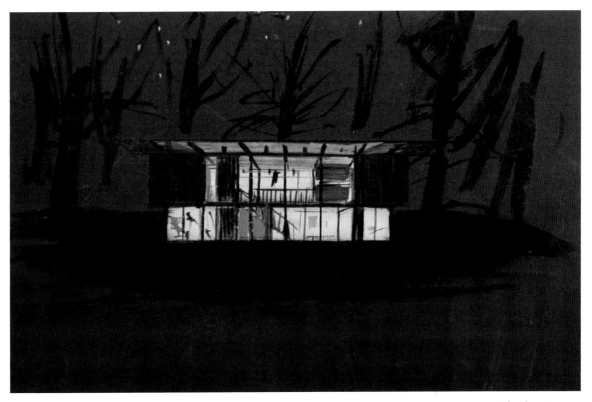

Charley Harper
Harper House, 1961
Gouache on illustration board, 4 x 6 in.

Charley Harper
Cardinal, 1960
Serigraph, 13 x 18 in.

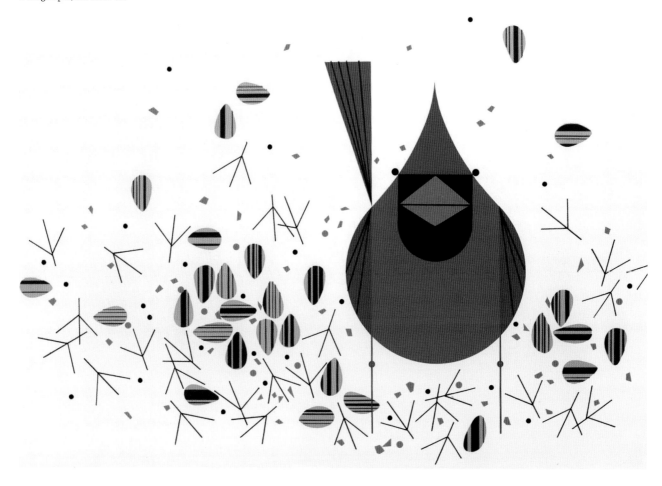

Charley's cardinal, along with the ladybug, evolved as a design motif recognizable throughout the world. Beginning in the 1950s, Edie painted a series of boldly contemporary, minimalist images featuring Old and New Testament stories. She liked to joke that her work "gave a new look to the old book." Along with acrylic paintings of cats and her own childhood memories, these remarkable Biblically based interpretations were representative of her later style.

Edie Harper
Coat of Many Colors, c. 1967
Oil on canvas, 34 x 34 in.

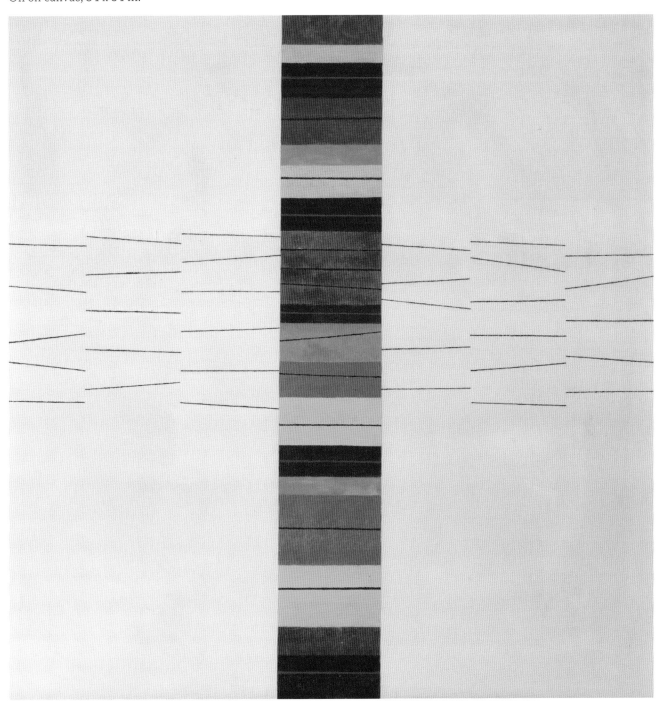

Scrapbook

A scrapbook of love notes and drawings, rhymes and keepsakes, from Buzzie to Edie Pie. "Geeo" and "Guyo" were other goofy nicknames they gave each other. Riley was Edie's middle name, and sometimes Charley spelled his name "Charlie" in the early years. This lighthearted "experiment in modern book design" gives a rare glimpse into the couple's budding love story.

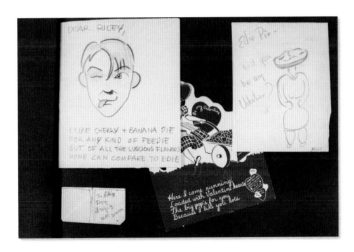

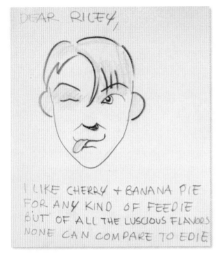

DEAR RILEY,

I LIKE CHERRY + BANANA PIE
FOR ANY KIND OF FEEDIE
BUT OF ALL THE LUSCIOUS FLAVORS
NONE CAN COMPARE TO EDIE

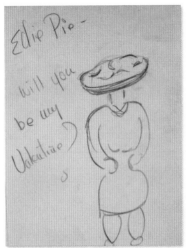

Edie Pie —

Will you
be my
Valentine?

YOU'RE DELICIOUS AS YOU ARE
TO ME IT DOES SEEM,
BUT I WONDER HOW YOU'D BE
WITH SUGAR AND CREAM.

(NO, YOU DON'T NEED SUGAR
AND YOU'RE ALREADY THE
CREAM).

I COULD SUIT MIKE ABEL FINE
IF I KNEW YOU WERE MY
VALENTINE.

A DISAPPOINTED LOVE—
ER, I MEAN,
CHARLIE

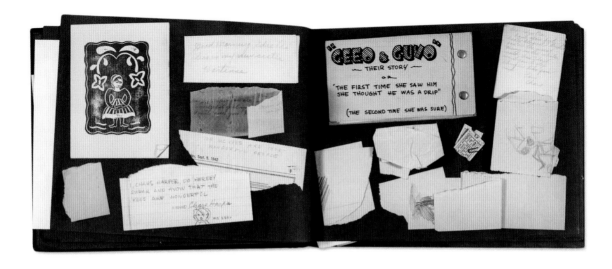

136

RAIN - THREE ARTS
FUN FOR TWO HEARTS

PARDON ME,
GIRL —

SILLY, ISN'T IT?

ART ACADEMY BALL
GOOD LORD—SOME BRAWL

CONEY ISLAND FLING
UP CAME EVERYTHING

TREASURE ISLAND THROW
NOW WE KNOW

AULT PARK
DARK LARK

SKATING AND RACE TRACK
SEE CARTOONS ON WALL
JUST OUTSIDE YOUR STALL

MISSED BUS
OH CUSS

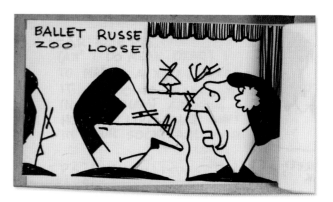

Chronology

1922 March 29: Edie born to Mabel, housewife, and George McKee, restaurant owner and salesman, Kansas City, Kansas

August 4: Charley born to Ulma, housewife, and Cecil Harper, farmer and feed mill owner, Frenchton, West Virginia

1939 May: Charley graduates from Upshur High School, Buckhannon, West Virginia

September: Charley enrolls at West Virginia Wesleyan College, Buckhannon, West Virginia

1940 May: Edie graduates from Wyoming High School, Cincinnati, Ohio

September 10: Edie and Charley meet on the first day of classes at the Art Academy of Cincinnati

1942 December: Charley drafted as infantry private first class in the US army; reports to Fort Chaffee, Arkansas; works on art for the army and himself as much as possible

1943 Charley undergoes basic training at army camps in Arkansas and Colorado; designated junior clerk; studies drafting and mapmaking at University of Delaware

May: Edie graduates from the Art Academy of Cincinnati

September: Edie begins working as photographer and technician in the photo lab of the US Army Corps of Engineers in Cincinnati

1944 Edie takes art classes at night to enhance her skills; cares for her ailing father

January 20–February 4: Edie selected as one of three former academy students to exhibit at the Modern Art Society, Cincinnati (renamed the Contemporary Arts Center in 1956)

September 7: Charley arrives in Cherbourg, France, as an infantry scout in a reconnaissance platoon in the Allied push to Berlin, Germany

1945 April: Charley and his fellow soldiers liberate Nordhausen concentration camp

July: Charley honorably discharged and returns to America on a troop transport ship

August: Charley trains at Camp Pendleton, California, anticipating orders to serve in attack on mainland Japan

Charley exhibits watercolors at Closson's department store, Cincinnati

1946 January–June: Charley studies at the Art Students League of New York

Summer: Charley returns to West Virginia

Fall: Charley re-enrolls in the Art Academy of Cincinnati

1947 May: Charley graduates from the Art Academy of Cincinnati; receives the Stephen H. Wilder Traveling Scholarship

Edie leaves her job at the government photo lab to help care for her father while continuing to create fine art

August 9: Edie and Charley marry in the parlor of Edie's parents' home in Cincinnati and depart on the "Great Honeymoon"

August 9–December: The Harpers drive across the continental United States and back—drawing, painting, and camping along the highway and stopping to visit relatives, former instructors, and art school friends

1948 Edie and Charley move into the McKees' home in the Cincinnati suburb of Roselawn; the newlyweds continue to assist Edie's father with his daily needs

Charley starts job at Studio Art, Cincinnati; begins freelancing for *Ford Times* magazine and other clients

Edie paints a wall mural, *Woodland Fauna*, in the children's area of the First Unitarian Church, Cincinnati

1949 Edie and Charley participate in the Modern Art Society, Cincinnati

October 10–November 24: Edie and Charley return to the Art Academy of Cincinnati for a course on color theory taught by the legendary Bauhaus instructor Josef Albers

1953 May 29: Edie and Charley's son Brett born in Cincinnati and named after photographer Edward Weston's son Brett

1957 Charley begins teaching illustration and design part time at the Art Academy of Cincinnati, a position that will last twenty years

1958 The three Harpers move from Roselawn to a contemporary home and attached studio designed and built by Rudy Hermes, surrounded by trees in the Finneytown suburb of Cincinnati

Charley illustrates *Betty Crocker's Dinner for Two Cook Book*, published by Simon & Schuster, New York

1961	Charley illustrates *The Giant Golden Book of Biology*, published by Golden Press, New York
	March 3–March 24: Edie participates in a solo photography exhibition titled *Edith McKee Harper: Exhibition of Photographs* at the Contemporary Arts Center, Cincinnati
1964	Charley creates a mosaic mural, featuring over one hundred animal species, for the John Weld Peck Federal Building, Cincinnati
1967	Charley joins the Frame House Gallery, Louisville, Kentucky, a national distributor of limited edition prints
	Charley commissioned to illustrate *Animal Kingdom: An Introduction to the Major Groups of Animals*, published by Golden Press, New York
1968	Edie asked to join Charley at Frame House Gallery as artist under contract; both Edie and Charley end relationship with Frame House Gallery in the late 1980s
1970	Charley's *Space Walk* ceramic tile mural installed inside the Cincinnati Convention Center (today the Duke Energy Convention Center); the design was one of his only abstract (nonrepresentational) works following his years at the academy
1974	Charley illustrates *Charles Harper's Birds & Words*, published by Frame House Gallery, Louisville, Kentucky
1986	Charley's *Web of Life* ceramic tile mural completed within Pearson Hall, the microbiology department building on the campus of Miami University, Oxford, Ohio; sales of a lithograph print based on the mural fund an annual scholarship awarded to an outstanding art student
1990–1994	Charley joins Mill Pond Press, Venice, Florida
1994	Charley illustrates *Beguiled by the Wild: The Art of Charley Harper*, published by Flower Valley Press, Gaithersburg, Maryland
1995	Charley and Edie commence self-publishing
1999	Edie illustrates the children's book *My Nose Is Running*, published by Flower Valley Press, Gaithersburg, Maryland
2002	Edie and Charley exhibit in *Cincinnati Modern: Art & Design at Mid Century*, Weston Art Gallery at the Aronoff Center for the Arts, Cincinnati
2004	The Art Academy of Cincinnati awards Charley and Edie honorary doctorates of fine arts

2006–2008	Charley exhibits in part one of *Graphic Content: Contemporary and Modern/Art and Design*, Contemporary Arts Center, Cincinnati
	Edie exhibits in part two of *Graphic Content: Contemporary and Modern/Art and Design*, Contemporary Arts Center, Cincinnati
2007	Todd Oldham produces the book *Charley Harper: An Illustrated Life*, published by AMMO Books, Los Angeles, California
	June 10: Charley passes away from complications of pneumonia at Miami Valley Hospital, Dayton, Ohio
	August–October: *Minimal Realism: Charley and Edie Harper, 1940–1960* exhibition, Cincinnati Art Museum
2008	*Charley Harper: Works on Paper, 1961–1970* exhibition, Country Club, Cincinnati
2009	September–October: *Charley Harper Original Paintings & Drawings* exhibition, Altman Siegel Gallery, San Francisco, California
2010	January 23: Edie passes away from congestive heart failure at Otterbein Retirement Community, Lebanon, Ohio
2011	June–September: Exhibition of Charley's work at Kunstverein, Hamburg, Germany
2012	January–February: *A Bird's Eye View* exhibition, College of Design, Art, Architecture, and Planning (DAAP), University of Cincinnati
2013	October–November: *Harper Ever After* exhibition, Art Academy of Cincinnati, includes Edie and Charley's work from their student days to slightly after
2014	Charley's *Space Walk* mural receives $196,000 in public funding for unveiling and restoration; walled over since the 1980s, the mural is now recognized as an icon by a unanimous vote of the Cincinnati City Council (The decision was the result of a prolonged campaign by Brett Harper, Duke Energy Convention Center general manager Ric Booth, the cf3 group and other preservationists.)
	August 1–3: LumenoCity public light show features Charley's images projected onto the façade of the Cincinnati Music Hall and paired with performances by the Cincinnati Symphony Orchestra.
Present	Charley and Edie rest together at Spring Grove Cemetery, Cincinnati

Harper Ever After

Exhibition, Art Academy of Cincinnati, 2013

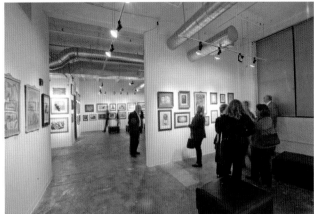

Index of Artworks

Page numbers in italicized type indicate artworks are discussed on those pages.

Charley